B R I T A I N I N O L D P H

AROUND
CLEVELAND

PAUL MENZIES

The
History
Press

I would like to dedicate this book to my wife, Jackie Menzies, who is always there for me; my brother Martin Menzies; the late Wilf Mannion, who became a good friend in his later years; and finally to two colleagues: Dave Mulholland and Keith Dodds, both proud citizens of Cleveland, but who sadly passed away far too early.

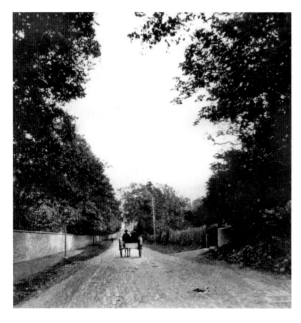

Pony and trap going up the Spital at Yarm.

First published 2009

The History Press
The Mill, Brimscombe Port
Stroud, Gloucestershire, GL5 2QG
www.thehistorypress.co.uk

British Library Cataloguing in Publication Data.
A catalogue record for this book is available from the British Library.

ISBN 978 0 7524 5136 7

Typesetting and origination by The History Press
Printed in Great Britain

CONTENTS

ACKNOWLEDGEMENTS

I give grateful thanks to all those individuals and organisations that have allowed me to copy and use their material, given their time and generally helped in my research. I have taken a great deal of time in tracing and establishing ownership of all material and ensuring that permission for reproduction in this work has been given, whether in copyright or not.

Permission to include material including images, map extracts and written material has been given by Arthur, Arnold and Winifred Dent, the late Leslie Dixon, the late George McDowell, the late Wilf Mannion, the late Adrian Ward-Jackson, Len Whitehouse, Reverend W. Wright, Julian Harrop at the ICI Collection at Beamish Museum, Jo Faulkner at Stockton-on-Tees Borough Council Museums Service, Steve Wild at Stockton Reference Library, the now defunct Cleveland County Council Planning Department, Middlesbrough Reference Library, David Tyrell and Janet Baker at Teesside Archives, Alan Sims at the *Evening Gazette Teesside*, Joy Yates at the *Hartlepool Mail*, and Steve Hearn at Ordnance Survey. All other material is from the author's own collection.

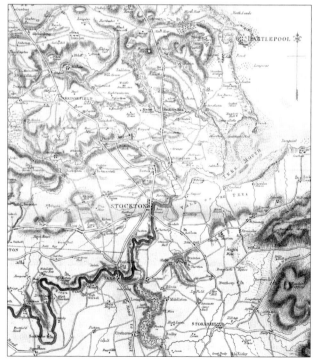

A map of the lower reaches of the Tees in 1828, which includes most of the area mentioned in this book. The Stockton to Darlington Railway is shown, but Middlesbrough is a farmhouse at this time and the area along the Tees is yet to be developed.

INTRODUCTION

It is almost twenty-five years since I first wrote a book looking at the history of Cleveland* and it is pleasing to note that there has been a consistent interest in this area in the years since then. Indeed, a great deal more evidence has come to light since then, enabling the history of Cleveland to be increasingly well documented. Suffice to say when I first began to research the history of the area there was often very little evidence available. This was particularly true of photographic sources: the need to preserve the past in a visual sense was not necessarily regarded as a priority by the owners of such material.

The excellent news is that awareness of the past has grown immensely in the last quarter of a century and, in the process, a lot of new material has come to light. In the realm of photography, there has been the discovery of many new wonderful images which, whilst not always providing new finds, can at the very least endorse our current knowledge. The use of photographic images is obviously crucial to a book of this nature. In this area there have been immense strides forward, with computer technology proving an invaluable aid in improving not only the quality but the range of images available.

Many of these images have been digitally restored using Photoshop. In doing so the sole aim has been to restore each image as closely as possible to its original state when first printed. Occasionally, in performing digital restoration, decisions have to be taken to include something which does not exist – for example, a missing part of an image. It is hoped that where this is the case you will agree the image has been sensitively restored. Indeed I hope you will not even be able to tell!

Research for a book involves many hours of looking through material and making decisions about what to include and, much more challengingly, what to leave out. This has been a labour of love for me as I have always been a historian 'by trade' through a university degree and the more specialised post-graduate study leading to my Master of Arts in history. My academic speciality – modern twentieth-century political history – ran parallel to an insatiable appetite for local history, and the history of Cleveland in particular. I was very fortunate in having a father who took me to Middlesbrough Reference Library from an early age and was prepared to wait patiently while I looked with fascination through huge volumes of old newspapers (no microfiche machines then). What I read inspired me, and took me through an imaginary window into another world called 'the past'. To read about events in my area a century before fired within me an endless desire to know everything that had happened. There was also the added edge called 'change'. To think that there was once a farm next to the clear flowing waters of a river on land which was by then row after row of terraced houses, with their gas-lit streets next to a heavily polluted stretch of water was just amazing. And that was it: a historian was born and that longing to find out about the past is still there today. As I became more knowledgeable my interest deepened and other sources beckoned, including the many months I spent looking at the diaries of Ralph Jackson of Normanby Hall. To actually hold a diary from the 1770s was a privileged experience.

Cleveland is an area which has seen an incredible transformation since 1800. A traveller coming over the Eston Hills two centuries ago would have looked from the top across a landscape far removed from that of today. Where we now have vast housing estates and a ribbon of industry along by the river, there would have been a patchwork of green fields and small villages with only the town of Stockton in the far distance resembling any sort of sizeable community. A small farmhouse would just be visible standing slightly elevated above the river which flowed nearby – today the urban sprawl of Middlesbrough covers that same area and much more. I find it quite amazing to read in the diary of Ralph Jackson of his being able to ride down across the fields to the river from Normanby Hall. The scenario of contrast between the rural past and today's urban world could be repeated many times. Eventually it borders on the edge of romance and fancy as the temptation looms for many of us to regard it as a better world then. It wasn't, of course – reading of some of the difficulties of dealing with illness alone should convince anyone of this – but it was so very different.

That is where this work comes in. I have not attempted to produce a complete history of Cleveland. I could not possibly hope to do this as there is far too much history not even mentioned due to lack of space. It is hoped however that this book may just make the reader stop and think for a moment about aspects of the world as it was in our area. Whether this is the pre-industrial world of the eighteenth and early nineteenth century or of more recent times is not really important. I think of this book as a signpost to aspects of the history of Cleveland with the images acting as a visual stimulus for that journey into the past.

Of course it goes without saying that a work of this nature would not come to fruition without contributions from many other sources. Individuals whom I need to mention include several from organisations that made information and evidence available for me to use from 1962 onwards. These include my maternal grandfather, John Lindberg, whose tales of Middlesbrough before the First World War are now preserved on tape forever; the late Wilf Mannion; Julian Harrop at Beamish Museum; Mark Rowland-Jones and Jo Faulkner at the Stockton Museum Service; Alan Sims at the *Evening Gazette*; Joy Yates at the *Hartlepool Mail*; the staff at Middlesbrough Reference Library, particularly Larry Bruce back in the 1980s; David Tyrell and Janet Baker, stalwarts of Teesside Archives; Steve Wild at Stockton Library; Jeff Wilkinson; the Ordnance Survey organisation; British Rail (as it then was) York; and of course Matilda Richards, my commissioning editor at The History Press, who has offered such good support during the writing of this work. If there are any unmentioned sources here I offer my grateful thanks as well as my apologies for failing to mention them by name.

Similarly, whilst I have attempted to ensure that there are no obvious mistakes in this work, I would like to apologise in advance for any errors that may have been made, factual or otherwise. Please let me know of any errors and I will update my records. In the same vein, if anyone has any more information or evidence about any aspect of the history of Cleveland that they would like to share, please get in touch, especially if you have any images that you will allow me to copy. With computer technology they can be copied in minutes and, in the case of damaged material, they can even be restored to a state which may even be an improvement on the original print! I have been pleased to provide digitally-restored images for a number of people. Also, in digitally preserving these images, they are being saved in a form in which they will not deteriorate.

Writing of any nature always impacts on those people closest to you and this is the case here. I would like to offer an enormous thank you to my dear wife Jackie, who has had to put up with many months of my rising at five o'clock in the morning to write before going off to work, as well as many rainy afternoons spent at the Reference Library in Middlesbrough. To her I owe a debt that I can never repay.

Paul Menzies, April 2009
m.menzies1@ntlworld.com

* The Cleveland referred to in this work is approximately the area that lies between Hartlepool and Saltburn, along the coast and westwards inland to Yarm.

1

OLD CLEVELAND IN DURHAM: THE NORTH BANK OF THE TEES

The area in South-East Durham before industry arrived …

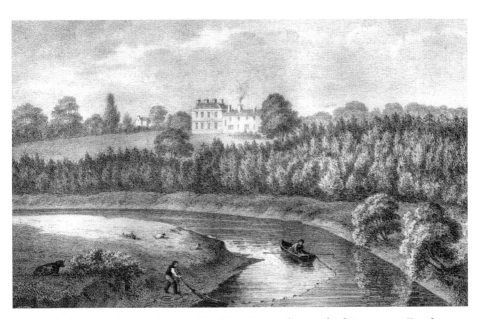

Preston Hall has stood on the banks of the River Tees in the parish of Preston-on-Tees for nearly 200 years. An impressive prospect, it was one of several 'country seats' in Cleveland. David Burton Fowler, a lawyer, acquired the land at Preston specifically to build the Hall in 1820. The location was well chosen; when it was completed in 1825 Preston Hall was much admired for its fine view across the bend in the river to Thornaby woods and the distant Cleveland Hills. David Fowler died aged ninety-two on 30 January 1828 and the Hall passed to his nephew, Marshall Fowler. A point of interest is that the Stockton to Darlington Railway ran through the grounds of Preston Hall until 1852, when it was diverted through Eaglescliffe.

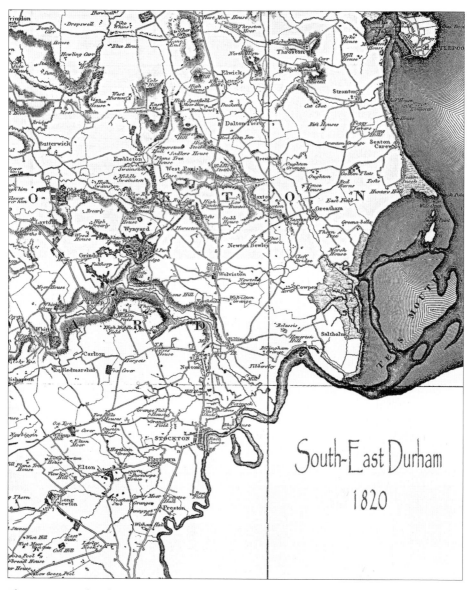

This extract is taken from Christopher Greenwood's map of Durham in 1820. There were four main towns in the area at this time: Hartlepool and Stockton in Durham, and Yarm and Guisborough in Yorkshire. By the eighteenth century, Yarm, like Hartlepool, was in decline. However, Stockton was gaining in importance as increased trading with London and Northern Europe and a demand for more ships fuelled the development of local ship building, which filtered into the regional economy as a whole.

The principal landowners in 1820 were the Church or wealthy individuals such as the Marquess of Londonderry at Wynyard. The River Tees, historically an administrative boundary between the two counties, dominated an area which, prior to the mid-nineteenth century, was relatively isolated, particularly close to the coast and the Tees estuary. With industry as yet relatively undeveloped, the local economy remained dependent on agriculture – generally mixed farming with some sheep farming on the salt marshes close to the estuary. One notable property here was Saltholme, a sheep farm belonging to the Prior of Durham.

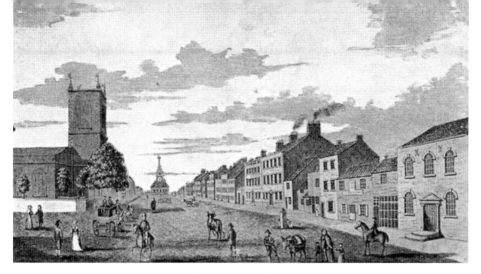

The relocation of the Customs Office from Hartlepool to the Red Lion Yard in Stockton in 1680 reflected the growing importance of Stockton, even in the seventeenth century. Despite the Seven Years' War and conflicts with America and France limiting trade, the town increasingly became a social and economic centre throughout the eighteenth century. The diarist, Ralph Jackson of Normanby Hall, wrote of many visits to Stockton in the late eighteenth century, to conduct his business and social affairs. Prosperity brought improvements to the town. A new parish church was built in 1712 while the Corporation of Stockton ordered the paving of the streets in 1717. The centuries-old tollbooth was replaced by an elegant new townhouse in 1735. Both buildings are visible in this image from 1785.

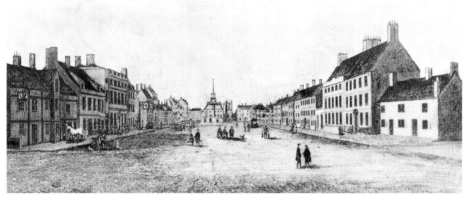

Improved trade links with London and Northern Europe in particular meant that ships carrying lead, wool and hides from North Yorkshire brought back imports of timber and other raw materials to be used in Cleveland's thriving linen industry. In 1718 seventy-five corn ships entered the port of London from Stockton – more than from Hartlepool and Sunderland combined. Stockton's development as a port led to the area east of the High Street, down to the river, being developed. A new road to link Finkle Street and Castlegate was built in 1706, whilst Silver and Bishop Streets date from this time. In 1730 the Customs Office, having already moved again in 1696, found a more permanent home close by the river, the £150 building costs being funded by the Corporation. An impressive new market cross with a 33ft-high Doric column, which dominates this view of the southern end of the High Street in 1785, was built in 1768 at a cost of £45.

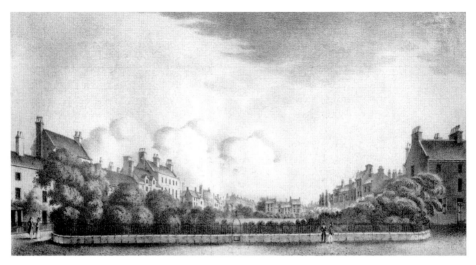

When the parish church was built in 1712, a piece of wasteland was purchased for a new vicarage. As the vicarage was never built the land became a garden or 'Green'. It was renamed 'The Square' to avoid confusion with nearby Thistle Green. With its elegant wooden railings and bushes, The Square became a very fashionable part of Stockton in the Georgian period. A theatre opened in nearby Green Dragon Yard in 1766. In this image from around 1829, Church Row is on the left, Paradise Row is in the distance and the road to Thistle Green is on the right.

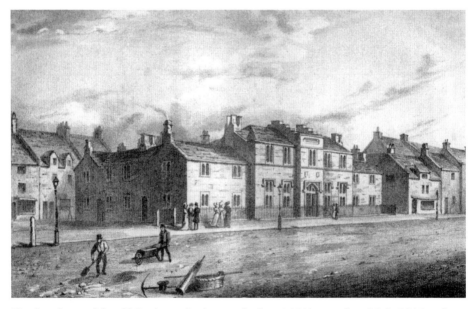

The demolition of the old Stockton almshouses (built in 1682) started on 1 July 1816 and they were replaced in around 1829 by the buildings shown here. The project was financed by a bequest of £3,000 from George Brown, a citizen and wealthy benefactor of the town. The new almshouses, built close to the parish church, were in Gothic style with a committee room, dispensary and accommodation for up to thirty-six widows and their families.

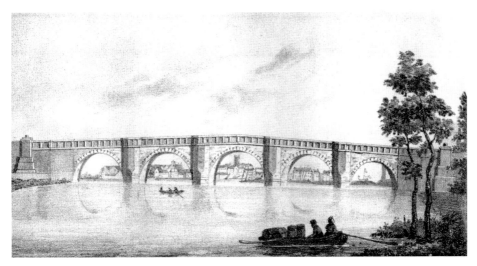

The ferry service at the site of the old castle was inadequate for a growing town. An impressive five-arched stone bridge was officially opened in 1771, saving six miles for travellers who no longer had to use the bridge at Yarm. Tolls financed the £8,000 building costs. The Trust were eager to recoup their money and opened the bridge early, as noted by Ralph Jackson on 5 October 1768 when he wrote that he 'rode along the New-bridg [sic] at Stockton, which has been passible [sic] for Horses & light Carriages for a month past, [although] the Battlements are not yet begun.' The 'battlements' (buttresses) to which Jackson is referring, can be seen in this view of the bridge from around 1820. Following extensive public unrest at the continued use of the tolls they were withdrawn in October 1819.

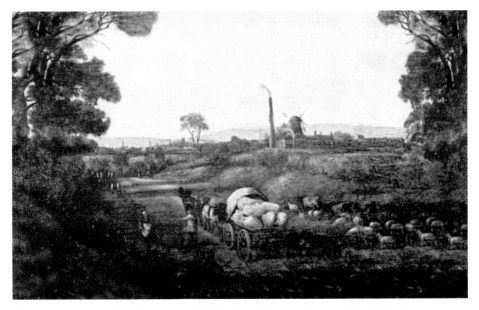

The two routes west from Stockton to Darlington, Bishopton Lane and Oxbridge Lane, converged west of the town at Two Mile House, after which they continued to Darlington. Bishopton Lane can be seen here in the early nineteenth century. A chimney at Stockton Ironworks on West Row, built in 1765, and the windmill, built in 1814 on Mill Lane (an extension of Dovecot Street), are visible on the horizon.

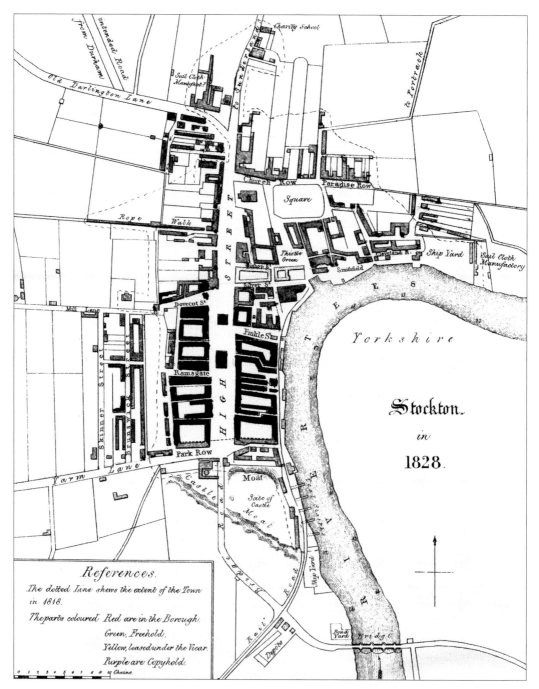

This map of Stockton in 1828 shows aspects of its economic development, with five coal staithes shown next to the railway as well as two shipyards and two sailcloth manufacturers – one next to the river and one close to the town on Old Darlington Lane (Brown's Bridge Lane). Any new housing tended to be infilling in populated areas. The first open development west of the High Street is shown here, a portent of future expansion. The only physical reminder of Stockton Castle is a castellated outbuilding used for agricultural purposes, although the site of the castle moat is shown.

Unlike the eighteenth-century development east of the High Street, development to the west was more gradual. The 1828 map (opposite) shows development from the 1820s, including Skinner and Brunswick Streets. However, much of the area was still rural, as shown here in this image of Brown's Bridge on Bishopton Lane, less than a mile from the town. There had been a mill on Brown's Haugh since 1786. In 1832 it was sold to Tommy Wren and is visible here in the distance.

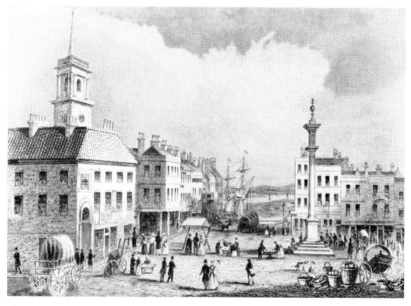

The early 1820s brought two days of public celebration to Stockton. The formal opening of the Stockton to Darlington Railway on 27 September 1825 was followed on Monday 24 September 1827 with a visit by the Duke of Wellington, who was greeted by a nineteen-gun salute and the ringing of church bells. This contemporary painting shows the town at that time: a flourishing market place, elegant Town House and stylish market cross, flanked by many fine buildings. The market place looks down Finkle Street to the River Tees and the distant 'Janny Mills' Island. This was one of several islands and sandbanks in the Tees, which existed before the river was straightened and improved.

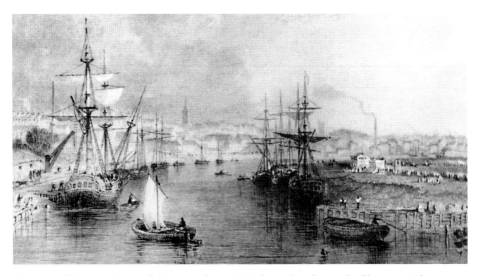

This view of Cottage Row and the riverside in 1832 shows how busy it had become. A horse-drawn carriage can be seen on the Stockton to Darlington Railway while a ship berthed at the coal staithes is taking on fresh cargo. A number of other ships are berthed at more distant wharfs. Both the Town House and the parish church are visible on the skyline, as is a chimney from a sail-cloth factory near Thistle Green. Across the river on Mandale Carrs is the grandstand of Stockton Racecourse, the venue for this ever-popular event for a number of years.

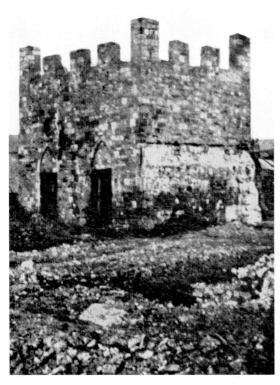

Originally a Norman manor house with a moat, Stockton Castle, as it was first referred to in 1376, was owned by the Prince-Bishops of Durham. The knowledge that King John stayed there in 1246, together with evidence from excavations in the 1960s, suggest an impressive structure. Although its precise role as a military building is uncertain, the castle had increased in size by the sixteenth century. Soldiers were garrisoned there in 1543 following the Pilgrimage of Grace and again in 1640 by Royalist forces. The castle remained a Royalist stronghold during the Civil War until 1644, when it was taken by the Scots under the Earl of Callendar after the Battle of Marston Moor. In 1647 the building was destroyed by order of Parliament, except for the castle barn (later described as a 'castellated cowhouse'), which survived until its demolition on 29 June 1865.

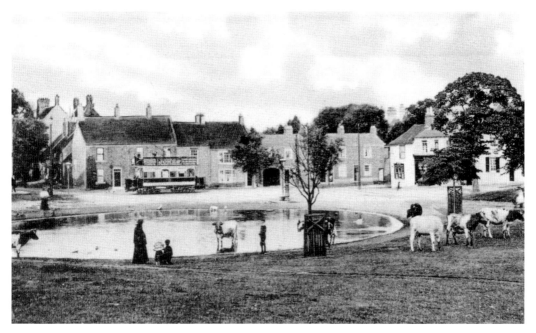

An archetypal traditional English village, with its duck pond and village green surrounded by cottages, Norton managed to retain its rural charm despite the urban development around it. Norton (the name means 'north settlement') was an important agricultural settlement in Anglo-Saxon times – in fact Stockton was part of the parish of Norton for many years. The village church of St Mary's is pre-Norman in origin, and opposite is the Hermitage, a building dating from the eleventh century. This view of the village from around 1904 is timeless, with its Georgian houses and animals grazing around the village pond.

Billingham, also a village of Anglo-Saxon origin, was on the main road from Stockton to Sunderland. Consisting of cottages around a green, part of which was common grazing land, the village remained virtually unchanged before 1914. This image from around 1902 shows one side of the green, East Row, a group of mainly Georgian buildings dominated by Brewery House. The other buildings included farms and a house occupied by George Raper, headmaster of the village school.

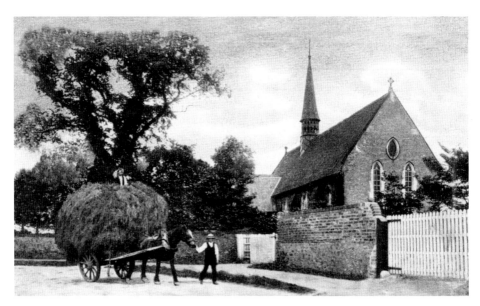

North of Billingham, on the Sunderland road, was the village of Wolviston. For many centuries it was part of the parish of Billingham. St Peter's Church, seen here, was built in 1876 at a cost of £2,315 to replace St Mary's, a church in the village which had fallen into disrepair. The local economy was dependent on agriculture, and a fully laden hay cart would have been a familiar village sight.

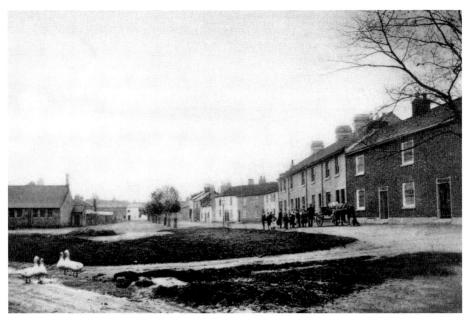

Greatham is probably best known for its association with the salt industry and for the Hospital of God, founded in 1273 by Robert Stichill, Bishop of Durham, to help the poor. This is a view of the houses in the village close to the green from around 1902. Greatham station was on the Clarence Railway, which linked Stockton and Hartlepool in 1833, although the actual station was some distance away from the village.

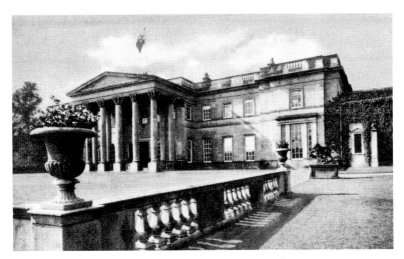

Wynyard Estate had been the residence of a succession of families since the thirteenth century, passing to the Vane Tempests in 1794. The Hall became associated with the Londonderry family after the marriage of Lord Stewart (the 3rd Marquess) to Francis Anne Vane in 1819, heir to the Wynyard Estate. Following their marriage the couple completely rebuilt the Hall but it was substantially damaged by fire in February 1841 while the Londonderrys were on holiday in Naples. Using the original designs the house was totally rebuilt; it was completed in 1848 and is seen here around 1905.

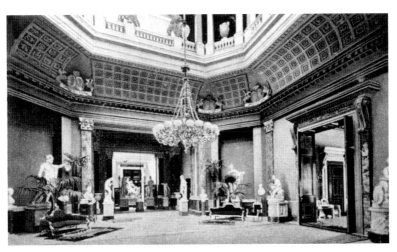

The Front Hall in around 1905. The octagonal statue gallery can be seen here surrounded by a dome with a beautiful stained-glass lantern in the centre. Around the hall are the many marble statues that were gathered during the family's Continental tours. Many famous people visited Wynyard including the Duke of Wellington in 1827 and Benjamin Disraeli and Sir Walter Scott in later years. On 2 September 1901 Winston Churchill, recently elected as an MP, made the first of several visits. King Edward VII held a Privy Council meeting here in 1903 – a rare hosting of the event in a private house. Several other royal visits have taken place, including a visit by Joachim von Ribbentrop, one of Hitler's top-ranking Nazi officials, in May 1937.

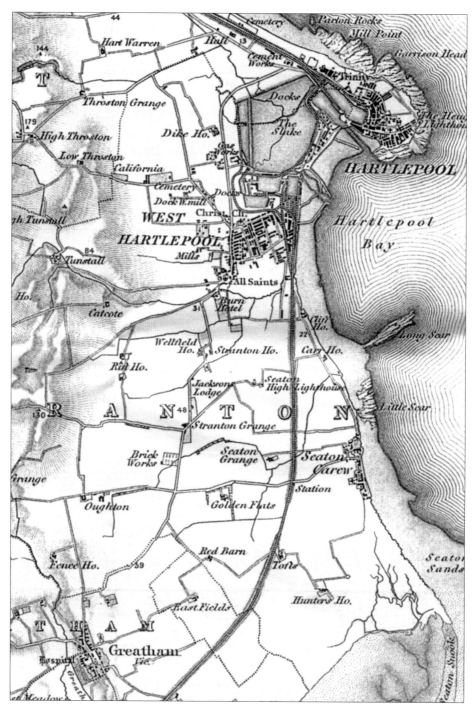

A map of the area around Hartlepool and Seaton Carew in 1857 shows the new development at West Hartlepool as well as the old medieval town of Hartlepool. Stranton has already been largely absorbed into West Hartlepool. The track north from the village of Seaton Carew, which went along the cliff edge to Stranton, is also visible. (Reproduced from the 1857 Ordnance Survey, One Inch series, with the kind permission of the Ordnance Survey)

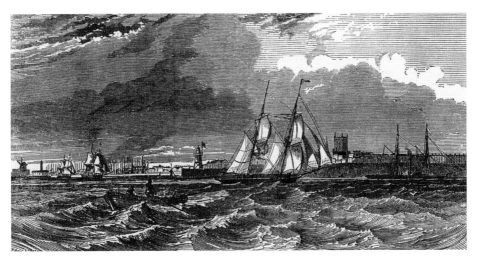

The other main town in south-east Durham was Hartlepool, a town with a long history. A monastery was built here in around AD 640 whilst in 1200 King John is said to have granted a charter to the men of Hartlepool, making them free burgesses. In 1216 they were granted the right to hold a market. The wars with Scotland in the late thirteenth and early fourteenth centuries meant that Hartlepool prospered as an important staging post and supply port. In the years following, however, the town experienced a substantial decline. By the 1800s, when this image was drawn, there was some partial economic improvement when a new dock was opened, but it was to be West Hartlepool, a new development to the south, which would enjoy greater economic success.

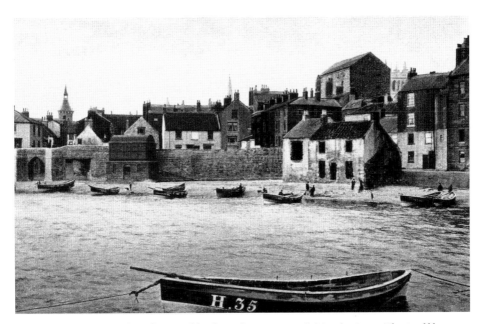

Hartlepool, with its sheltered natural harbour, has a strong fishing heritage. The twelfth-century Town Wall, which was substantially rebuilt in the fourteenth century, is shown here in around 1900. Sandwell Gate, an opening which gave fishermen access to Fish Sands, the part of the beach where they kept their boats, is visible on the left of the wall.

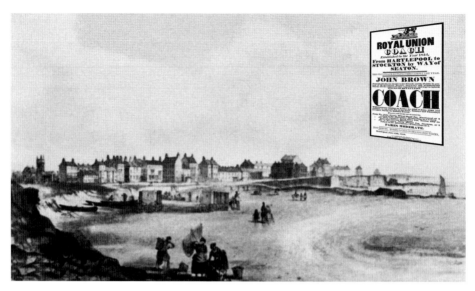

William Tate described Seaton Carew in 1812 as a 'watering place of high estimation' for important families, reflecting the development of the small fishing community in the eighteenth century as a fashionable resort patronised by wealthy Quaker businessmen. Tourism took its place alongside fishing as the major source of income for villagers.

A twice-weekly coach service, the 'Darlington and Seaton Diligence', operated during the summer months from 1783, with other coach services starting soon after from both Stockton and Sunderland. The Stockton to Hartlepool Railway, which opened in 1836, brought more people to the resort. This image of Seaton Carew from around 1847 shows a number of bathing machines on the beach, whilst the inset is a poster advertising a coach service to the resort, in 1834.

A narrow track from Seaton Carew winds its way along the cliff edge, *c.* 1864. When the new town of West Hartlepool was built, this track was used by those on foot or horseback. It followed a route through the farmyards of Carr House and Cliff House and on to Stranton. A formal road was proposed in 1871, but a public petition successfully argued that it was extravagant and unnecessary and so it was 1882 before a direct road link between Seaton Carew and West Hartlepool was finally completed.

2

OLD CLEVELAND IN NORTH YORKSHIRE: A REMOTE, INHOSPITABLE PLACE

The area in North Yorkshire is now examined …

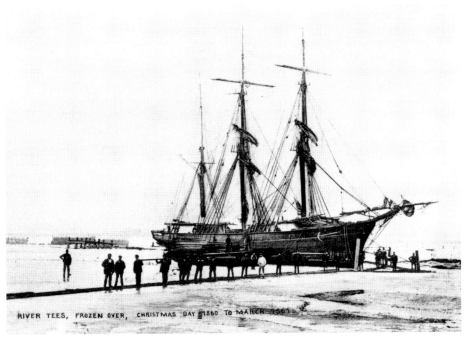

RIVER TEES, FROZEN OVER, CHRISTMAS DAY 1860 TO MARCH 1861

The River Tees, one of the defining physical features of Cleveland, has been moulded and shaped by man in the last two centuries, more than at any other time in history. This image, dated 'Christmas 1860 to March 1861', depicts a ship icebound on the river with some of the crew close by. Records show that there was a severe winter across the country in 1860/1, with the temperature falling to −12°C on Christmas Day 1860. This was followed in January 1861 by a frost so intense that the river was closed for a month at Stockton.

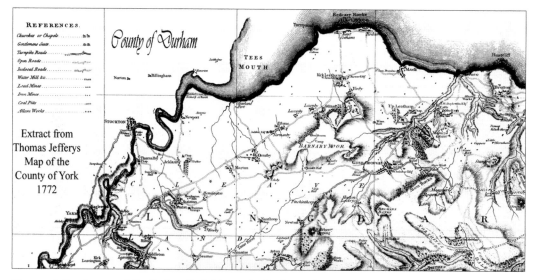

REFERENCES.
Churches or Chapels
Gentlemens Seats
Turnpike Roads
Open Roads
Inclosed Roads
Water Mill &c.
Lead Mines
Iron Mines
Coal Pits
Allum Works

County of Durham

Extract from
Thomas Jefferys
Map of the
County of York
1772

Thomas Jeffery's map of North-East Yorkshire in 1772 shows the area defined as Cleveland in this work. Few settlements are close to the river but several communities of Saxon and Viking origin, including Marton, Ormesby and Eston, lie on the road from Yarm to Marske. Navigation of the Tees up to Stockton was difficult with its narrow shallow channels and sandbanks; it was also lengthy, as the two large meanders of the river at Mandale and Portrack still existed in 1772. Cargoes could be unloaded further downriver, either at Cleveland Port (later Cargo Fleet) or at Newport, where they could be stored and then taken by smaller boats up to Stockton.

The map notes the 'seats' of several landowning families including Acklam Hall (Hustler family), Normanby Hall (Jackson family) and Kirkleatham Hall (Turner family), whilst only Middlesbrough Farm exists where the great Victorian boom-town would later be created. The local economy was mainly dependent on agriculture. but a number of mining concerns (mainly alum) are visible on the map. The main route is the ancient road from Durham to Whitby, which passed through 'Gisborough', one of two towns on this map. This route had been considerably improved for travellers with the new toll-bridge at Stockton. The other town on the map is Yarm, once important regionally but now in decline. The coastal area is remote, populated only by small fishing communities including East Coatham, Redcar, Marske and Saltburn. Not surprisingly, given the topography, the area was victim to the widespread smuggling of contraband by peasant and country squire alike, exasperating the often undermanned Customs officers.

Opposite above: Yarm owed much of its importance to being the lowest bridging point on the Tees until 1771, when Stockton Bridge opened. Yarm's hinterland stretched as far as Richmond and the Dales and many routes converged here. A wooden bridge had existed in Norman times, before being replaced by a stone structure built by Bishop Skirlaw in 1400. The iron bridge shown in this line drawing was built in 1805 to replace the stone bridge, but when the south abutment of the structure collapsed on 13 January 1806 it was decided to retain and widen the old stone bridge!

Opposite below: This painting shows Yarm in around 1850, soon after completion of the viaduct carrying the railway from Leeds to Stockton. This was seen as an important development in trying to arrest the town's economic decline. Although the viaduct brought many construction jobs to the town and provided an important link to other areas, Yarm never regained its economic dominance. Ironically, hopes of a revival of Yarm's shipping trade and port activities were actually ended by the railway, which was faster and cheaper to use and therefore resulted in a decline of the transportation of goods by river.

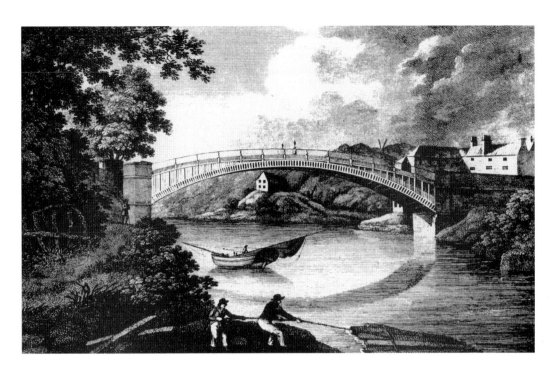

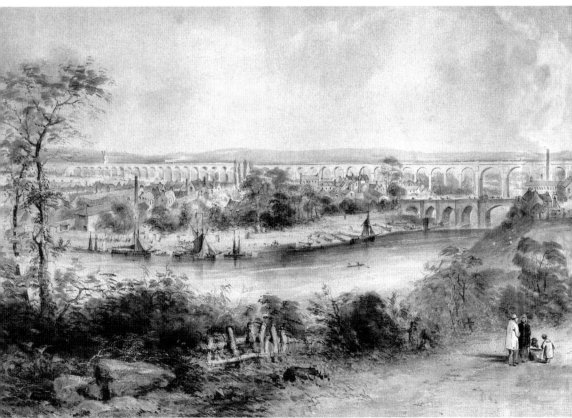

23

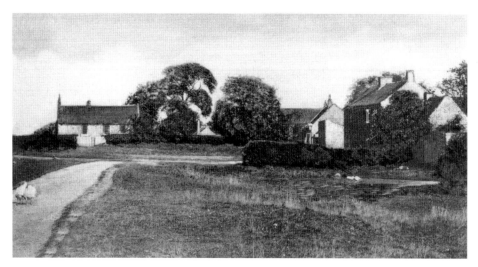

Some towns in this area were the visions of entrepreneurs, while others have much deeper roots. Thornaby, for example, was a small village of Viking origin until the mid-nineteenth century. This view of old Thornaby village in around 1900 shows its Norman church, houses around a green and a duck pond to complete the traditional English village. Events changed this community very little across the centuries until it was eventually encircled by South Stockton, a new settlement arising from a Victorian industrial development, with the two communities merging to become Thornaby-on-Tees in 1892.

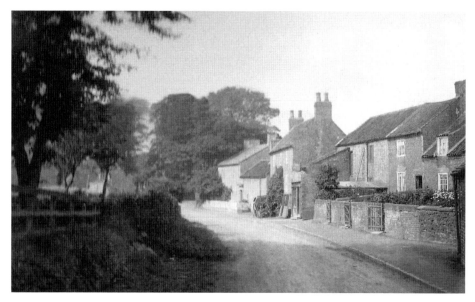

Another long-established village south of the Tees is Stainton. Like Thornaby it was eventually outgrown by communities around it. The manor of Stainton, mentioned in the Domesday Book, once included Acklam, Thornaby, Hemlington and Ingleby Barwick – all now urban communities in their own right. The Church of St Peter and St Paul in Stainton originally dates back to the pre-Norman period, but was renovated in the nineteenth century. James Cook and Grace Pace, the parents of world-famous explorer Captain James Cook, were married here on 19 October 1725.

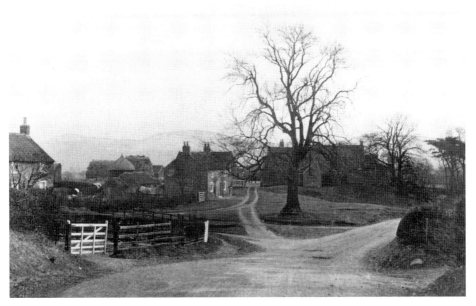

Low Green, Seamer, is seen here in the early 1900s. A scattered agricultural community, Seamer stretches alongside the road from Hilton to Stokesley. This image shows a timeless scene in a community in which little has changed across the centuries.

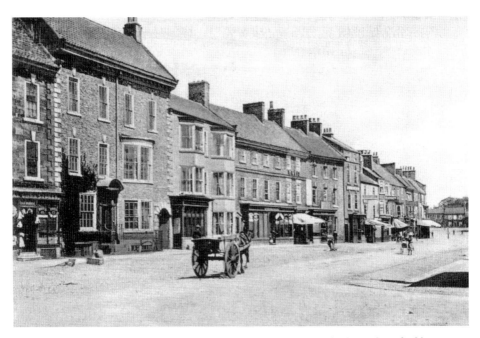

First granted a charter to hold a market in 1223 by Henry III, Stokesley is described by Ord as a 'handsome neat town, consisting principally of one main street, quite equal in its buildings to either [Gisborough or Yarm].' The town is known for its Georgian architecture, seventeenth-century Pack Horse Bridge and Manor House. The High Street is seen here in around 1900, with College Square (also called High Green) in the distance.

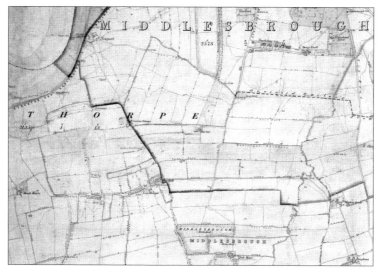

This 1856 map shows the area south of the new town of Middlesbrough situated at Middlesbrough Farm. The small settlements of Ayresome, Linthorpe and Newport – all of which would be absorbed into the new town, are also shown. It is fascinating to see that Linthorpe Road, well known throughout the region, was then a country lane. A Sailor's Trod – pathways used by sailors throughout the centuries – crosses the map. There is no direct road to Stockton; access was still via the hamlets of Linthorpe and Acklam. However, in 1858 the towns were linked by a route nicknamed 'The Wilderness Road' by local residents because of the desolate reclaimed marshland it crossed. (Reproduced from the 1856 Ordnance Survey, Six Inch series, with the kind permission of the Ordnance Survey)

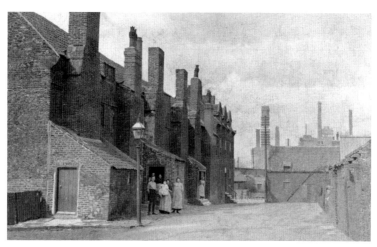

Gibbon's 1618 plan, the Hustler Estate Plan in 1716 and the 1856 map all show a ferry at Newport. The landing stage was close to Newport House (seen here at the end of the row of houses), a granary built in the seventeenth century by the Hustler family of Acklam to be used to store cargoes from ships which couldn't get up to Stockton. In this view the river is on the left of the buildings and the ironworks are in the distance. The final traces of old Newport finally disappeared in the early 1930s with Newport House and adjacent farm buildings being demolished during the construction of Newport Bridge.

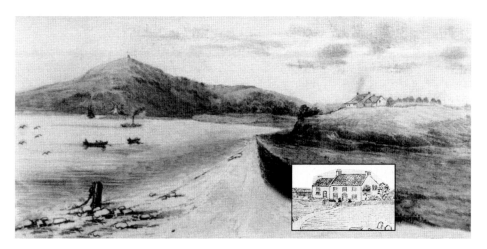

This digital simulation, created from the image below, gives an impression of the area before the railway was extended in 1830 along the southern bank of the Tees to a site close to Middlesbrough Farm. The river is not yet contained within the narrow channels of later years. In the distance lie the Cleveland Hills, with the beacon erected on Eston Nab during the Napoleonic Wars also visible. Further downriver the windmill and the granary warehouse, which offered an unloading point for ships at Cleveland Port (later Cargo Fleet) are both visible. They sailed from there too. Ralph Jackson wrote in his diary for 4 December 1787 of seeing 'the Sloop Fox haul from the Granery [sic] at Cargo Fleet: loaded with corn ... bound for London.' The inset shows Middlesbrough Farm in around 1808, the year that the Parrington family, the farm's last tenants, moved there.

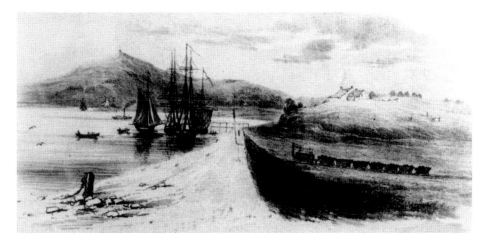

The problems of using Stockton as the main shipping port for exporting coal from the Durham coalfield quickly became apparent. Extending the railway downriver would overcome the distance from the sea and deeper water would allow larger ships to be used. Originally the Stockton and Darlington Railway intended to use Haverton Hill as the new shipping point for coal but abandoned this in favour of using Middlesbrough. This 1830 drawing shows the new branch railway to a new shipping point called Port Darlington and the slightly elevated site of Middlesbrough Farm. A shrewd consortium of Quaker businessmen, anticipating the influx of people to come, purchased 527 acres of adjacent land (including Middlesbrough Farm) in May 1830 for the purpose of building a new town in which they could live.

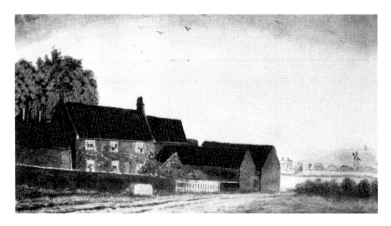

Swathers Carr (or Swatters Carr), a farm which stood at the corner of Linthorpe Road and Southfield Road, is shown here in around 1870. Mentioned as early as 1618 on John Gibbon's plan of Middlesbrough, it was one of a number of farms south of Middlesbrough Farm. Swatters Carr was still being farmed in the mid-nineteenth century but as Middlesbrough expanded southwards parts of the farm estate were gradually sold off to building developers. Middlesbrough Cricket Club used part of the land between 1857 and 1874 and the Cleveland Agricultural Society held their annual show there in 1879, but by 1900 the farm was no more. This image shows the farmhouse looking south towards the mill on Acklam Green Lane and new housing along Marton Road.

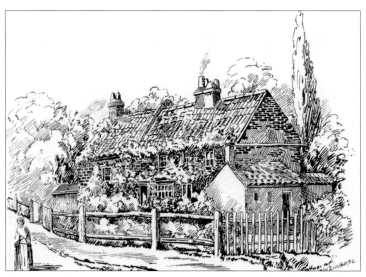

Although the exact origins of Linthorpe, like many other local communities, are lost in time, it is probably of Saxon or Viking origin. Two derivatives of the modern place name 'Levingthorpe' and 'Levynthrop' exist in church records of the post-conquest era. John Gibbon's 1618 plan of Middlesbrough shows Linthorpe as a community situated along the modern Burlam Road, with Linthorpe Green being a long strip of land close to where the cemetery is today. The Hustler Estate Plan of 1716 shows Linthorpe as houses in two rows, each dwelling standing in their own 'garth' or enclosed plot. This late nineteenth-century drawing by J.S. Calvert shows some of the cottages in 'Old Linthorpe', a name used to distinguish the ancient community from the newer nineteenth-century development.

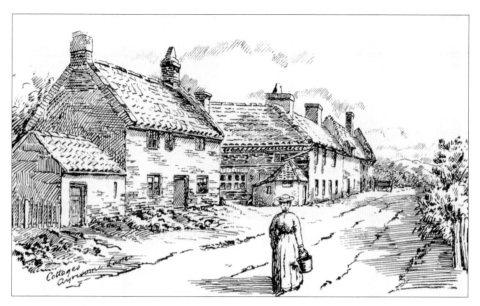

Less than a mile to the south of Newport was the hamlet of Airesome (Ayresome), a diminutive collection of seventeenth-century cottages which, like those at Newport, were part of the township of Linthorpe. This image, also from a sketch by J.S. Calvert in around 1898, is looking south towards West Lane. The turning beyond the first cottage is the modern junction of Ayresome Green Lane and Ayresome Lane. The cottages, which existed into the twentieth century, were recalled as being very primitive, constantly damp, with only an oil lamp or candles for lighting and having an earth closet some distance away.

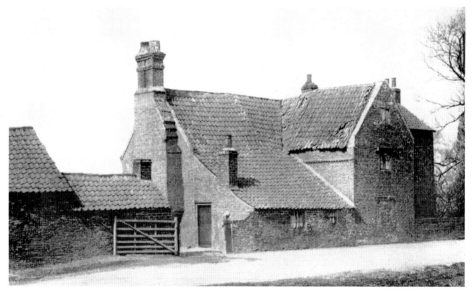

Close to the village of Airesome stood Airesome Grange Farmhouse, shown here in around 1900. The farm was located on Ayresome Green Lane, close to the modern main vehicle entrance to the former Middlesbrough General Hospital. The farm survived into the twentieth century, being demolished just before the start of the First World War.

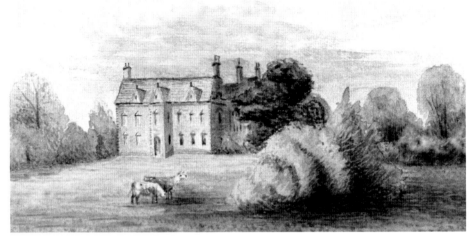

The Acklam Estate was bought by William Hustler of Bridlington in 1637. His grandson, also William Hustler, built Acklam Hall between 1680 and 1683. Originally a very formal building surrounded by elaborate formal gardens, the Hall appears here after the alterations of 1845. Restoration formality was replaced by a new 'Gothic' architectural style featuring gables and turrets. Attic rooms and a new porch were added, decorated with Gothic gables. The gardens were altered, with large lawns laid and woods planted close to the Hall. Further alterations in 1912 restored some formality. The estate, including the Hall, was sold in 1928. The Hustler family owned a large part of the land up to the river and were responsible for the building of the granaries and several other buildings at Newport.

Another village of Saxon origin, Ormesby, was a settlement on the road from Yarm to Guisborough. Various families owned land here including Robert de Brus, the Percys of Northumberland, the Conyers and the Strangeways, before the long-standing association began with the Pennyman family from the late sixteenth century. This view shows the village from the west in around 1890, with the eighteenth-century almshouses on the left. Despite the rapid expansion of nearby Middlesbrough, Ormesby retained many of its village features well into the twentieth century, due mainly to the stewardship of the Pennyman family.

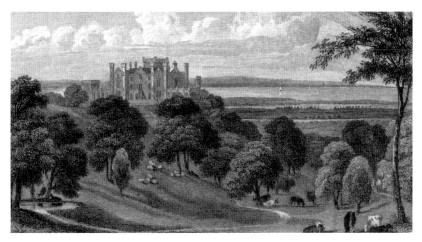

These two images of Wilton Castle in 1829 (above) and in the 1840s (below) are remarkable because together they provide a perspective of almost the whole of the lower reaches of the Tees in the early part of the industrial era. This 1829 image shows boats sailing in the river mouth – extremely wide compared with the modern-day estuary; note the distant shores of south-east Durham. Wilton Castle was originally built in the fourteenth century on the site of a manor house belonging to the Bulmer family. By the eighteenth century, Wilton Castle and its lands were in a poor state. When the estate passed to Sir John Lowther in 1824, he instigated a lengthy programme of restoration.

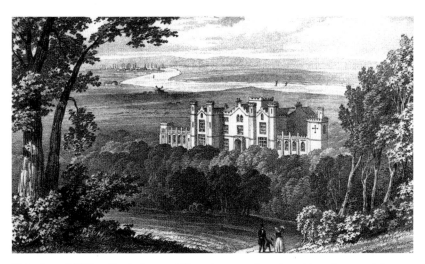

This view of Wilton Castle from a different perspective almost twenty years later shows the windmill at Cleveland Port and, beyond, the river to Middlesbrough, still very wide compared to later years. Very little sustained land reclamation took place along the estuary before the nineteenth century, although in 1777 Sir James Lowther of Wilton Castle financed a scheme costing £60,000 to reclaim part of the Wilton estate between Cargo Fleet and East Coatham. However, towards the end of the construction of the embankment, the workforce, having been unpaid, dispersed elsewhere, leaving the work unfinished. A great storm washed away most of the unfinished work, leaving the scheme beyond repair.

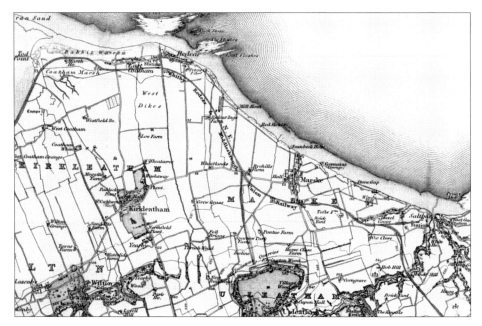

This map, from around 1860, shows the coast from Coatham to Saltburn and the relative isolation of communities within the area. Both Coatham and Redcar were fishing villages with medieval origins, whilst Coatham was also a port for many centuries. No direct road link existed from Redcar to either Marske or Saltburn and local inhabitants often walked along the sands. In the nineteenth century, Coatham and Redcar both rivalled each other as 'desirable watering places and sea-bathing resorts,' particularly as the opening of the railway from Middlesbrough to Redcar on 4 June 1846 brought many more visitors to the area. (Reproduced from the 1857 Ordnance Survey, One Inch series, with the kind permission of the Ordnance Survey)

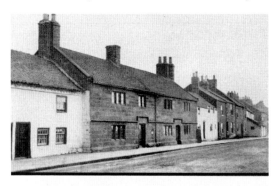

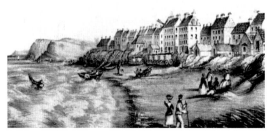

The upper view of Old Coatham in around 1900 includes one of the oldest buildings in the village, thought to date from 1698. The lower image shows Redcar in around 1854, with fishing boats out at sea and visitors using bathing machines installed on the beach. There was no esplanade at this time so the rear of houses on the east side of the High Street faced on to the beach. In the distance, looking south, the cliffs of North Yorkshire are visible, including those at Huntcliff and Boulby.

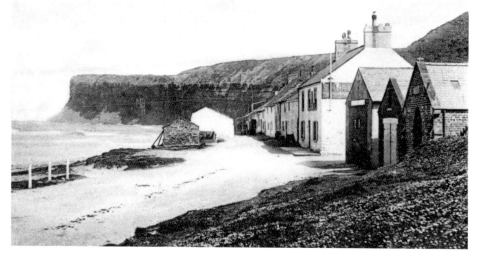

Old Saltburn, a fishing village at the foot of Huntcliff, seen here in around 1904, is quite distinct from the resort developed by Henry Pease's Saltburn Improvement Co. to capitalise on the new railway link to Middlesbrough in 1861. The long sandy beaches stretching north to Coatham coupled with high cliffs riddled with hidden caves to the south made it an ideal location for smuggling. Customs officers were often hopelessly outnumbered and confrontations were often violent. In December 1774 a command of Royal Dragoons from York had to be stationed at Marske to help stem the illicit trade. On 19 February 1780, the *Newcastle Courant* reported that more than seventy men rowed ashore from a ship to take back 'liquors seized at Redcar' by Customs officers, and that many shots were fired.

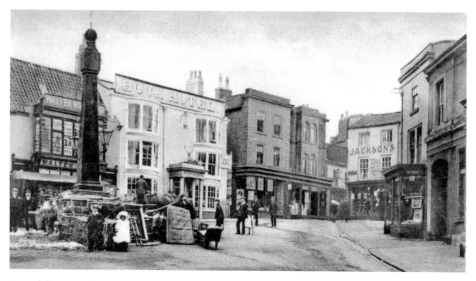

Daniel de Foe in his 'Tour through the British Islands' described Guisborough as a 'small market town, pleasantly situated ... [with] a very good manufacture of sailcloth.' Listed in the Domesday Book, Guisborough was on the route between the important religious centres of Durham and Whitby. Guisborough Priory was founded in 1119 by Robert Bruce and dominated life within the town before being largely destroyed in the Dissolution of the Monasteries. A Grammar School was founded and endowed by Thomas Pursglove in 1561. The local economy was essentially based on agriculture and mining, chiefly alum and Cleveland ironstone. The main route through the town was Westgate. The Market Cross, a popular place for local people to meet, is seen here in around 1910.

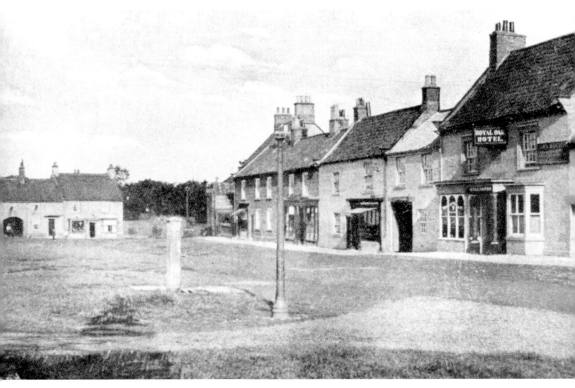

Ayton was described in 1801 as a 'considerable village, being nearly a mile in extent from east to west' with more workers involved in 'trade, manufacture or handicraft than in agriculture.'

A major employer during the seventeenth and eighteenth centuries was the linen industry. By 1850 however, increased competition from Lancashire and more lucrative employment available locally meant that numbers had dwindled. Another local industry was alum mining. Although this had declined by the late 1700s due to reduced market prices for alum, it was revived with the opening of the Nunthorpe to Battersby rail link in 1864. This made the mining of local whinstone and ironstone a viable economic proposition and this became a major employer well into the twentieth century.

Ayton is well known for its association with Captain James Cook, whose father lived in the village. Cook, having landed back in England from his first voyage on 12 July 1771, did indeed visit Ayton, as Ralph Jackson records in his diary for 26 December 1771 that he spent all day visiting a friend in Ayton (and that) 'this afternoon came Capt. Jas Cook (and his wife) whose father lives in this town.'

3

WHERE THERE'S GRIME, THERE'S MONEY

Travellers often remarked on Cleveland's stunning industrial vista: demonic lights and chimneys belching out smoke, which at times seemed to embrace whole communities …

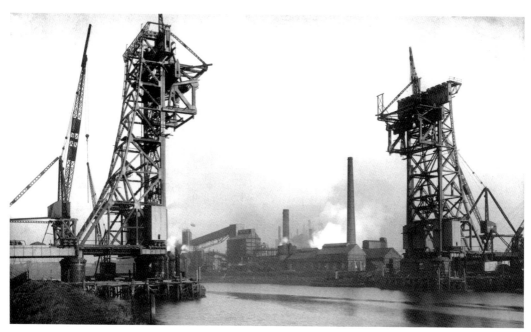

This view exemplifies the smoky, grim nature of the lower Tees valley in the 1930s. Middlesbrough's industrial skyline is visible behind the partially constructed Newport Bridge in this photograph from 26 October 1932. Known as the Ironmasters' District because of the large number of ironworks there, this area of reclaimed marshland stretched from Newport to the Transporter Bridge. Smoke belches from the chimneys over the densely populated streets of terraced housing nearby.

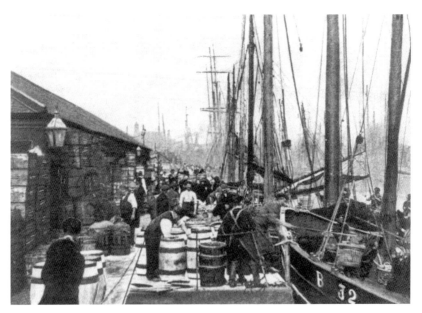

Hartlepool's long association with the fishing industry continued well into the twentieth century. The Fish Quay, seen here during the 1920s, was still a leading employer in the town. Fish from Hartlepool was renowned for its freshness, the speciality being herring. In this busy scene barrels are rolled alongside ships as fish are unloaded and fishermen get boats ready for their next trip. Fishing boats from a large number of ports visited Hartlepool to unload their catch. It was not unknown for women from the Scottish ports to come here for employment in preparing the catch for selling on.

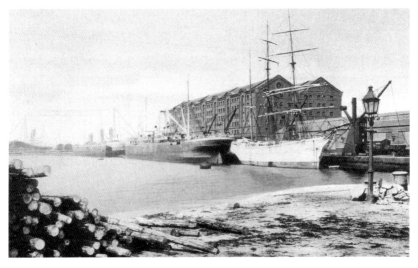

Several ships stand in Central Dock, West Hartlepool, in around 1910, one of several docks at the port. At this time, West Hartlepool was a very busy port handling a number of different cargoes. There were strong links with the Baltic and Scandinavia and timber was one of the major cargoes handled by the port. In the left foreground a cargo of logs has been stacked awaiting further transportation.

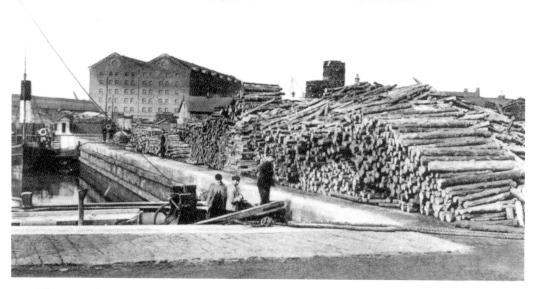

The original West Hartlepool Harbour and Docks opened on 1 June 1847 amidst great celebrations and a procession of sea vessels after the dock gates had opened. Union Dock (shown here) and Central Dock (shown previously), both opened in 1880, handling a variety of cargoes including timber for use as pit props in the mining industry and iron ore for the rapidly developing local iron and steelworks. This view shows No. 8 Warehouse, East Quay, Union Dock.

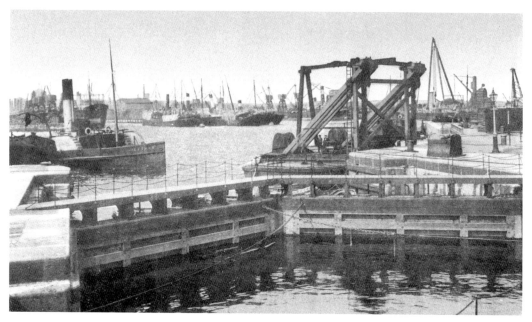

Another view of Union Dock, with the vast physical extent of the docks clearly visible as they stretch way into the distance. Modern shipbuilding at Hartlepool began in 1836 and shipbuilders became renowned for the quality of their ships. Company names such as William Gray & Co. Ltd, which opened in 1874, became synonymous with the history of shipbuilding at the port.

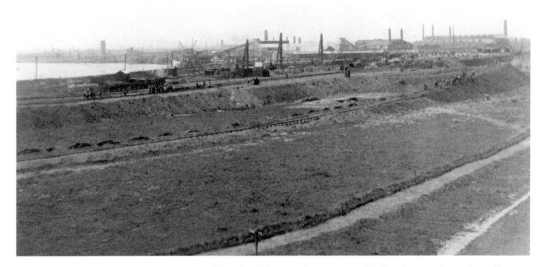

The development of industry on the north bank of the Tees began east of Billingham, where the Bell Ironworks had opened in 1854 at Port Clarence, whilst salt works, brick companies and a cement works were all established at Haverton Hill before 1914. The need to replace ships sunk during the First World War led in 1917 to the building of the Furness Shipyard at Haverton Hill. This view, taken during the construction, looks towards the site of the yard with two important industrial sites, the Pioneer Cement Works and Tees Salt Factory, in the distance.

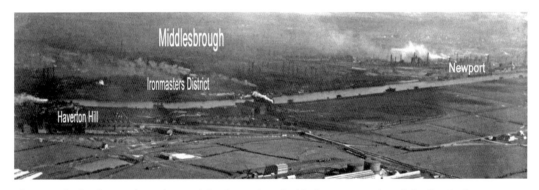

The growth of industry along the north bank continued with the construction of the Synthetic Ammonia and Nitrates Ltd factory close to Billingham. This aerial view from the early 1920s shows the development of industry in the area with the Synthetic Ammonia and Nitrates factory visible at the lower edge of the image. The Tees Salt Works, Pioneer Cement Works and Furness Shipyard are also visible. Across the river the extent of the Ironmasters' District can be seen, despite being largely obscured by smoke.

Opposite above: Synthetic Ammonia and Nitrates Ltd was always under pressure to begin operations as soon as possible at Billingham, but after No. 2 Unit became operational this pressure switched to other developments. By January 1924 the sulphate plant was operational and by 1925 'systematic development of the site with plants capable of indefinite expansion was being planned.' Within five years the factory would be acclaimed as one of the world's largest, with an output of 2,000 tons of nitrate per day. No. 3 Unit was operational by early 1928 and Nos 4 and 5 Units were to follow. This view from around 1925 looks north to the Haverton Road, with another phase of construction underway next to the boiler plant.

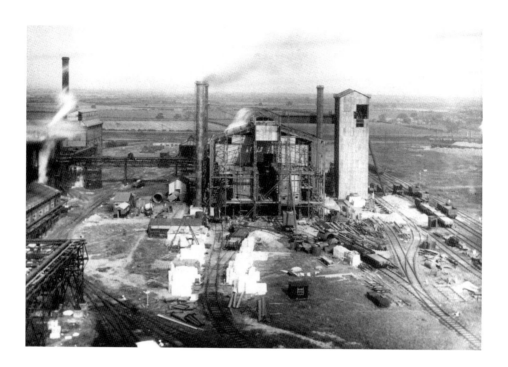

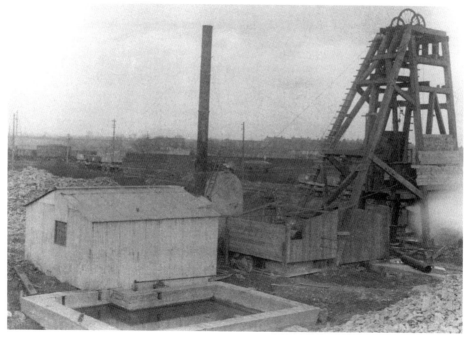

Detailed knowledge of the presence of anhydrite was not known when the site was purchased in 1920, and the mining of such an essential raw material *in situ* was not foreseen. However, after a 28ft seam of anhydrite was proved in November 1925, discussions at Billingham quickly concluded that the anhydrite was a 'gift of the Gods', which could prove to be of invaluable use to the company and that mining should begin as soon as possible. This is the head of the shaft on 30 December 1926. It was closed in 1971.

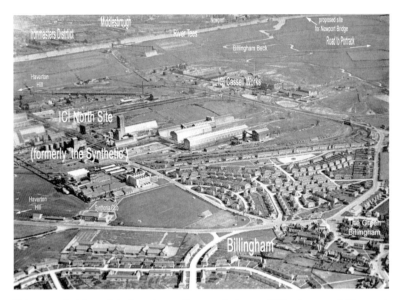

This remarkable aerial view shows the area between Billingham and Newport in around 1931. The lower edge of the image shows old Billingham village, with the ongoing construction of housing around Bedale Avenue also visible. Close to the original Synthetic Ammonia and Nitrates factory site there are also new works on the Billingham South site (Cassell Works) – by 1931 all were part of the newly formed ICI. It is interesting to note that the area around Billingham Beck, across to Portrack, remains rural. Closer to Billingham, Chilton House (the main offices of ICI at Billingham), the housing around Roscoe Road and the new Synthetic Club are all visible.

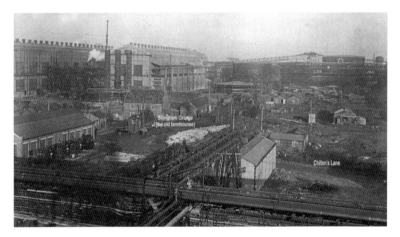

This image from the mid-1920s illustrates the vast scale of the development of ICI at Billingham. This view shows in some detail just how the area around Billingham Grange (a farmhouse less than a decade previously) had changed and been developed. The gardens and orchards at the farm have gone; the original farmhouse is dwarfed by new buildings all around it. Old Chilton's Lane can still be seen but only a solitary tree and bits of hedgerow show it was ever a country lane.

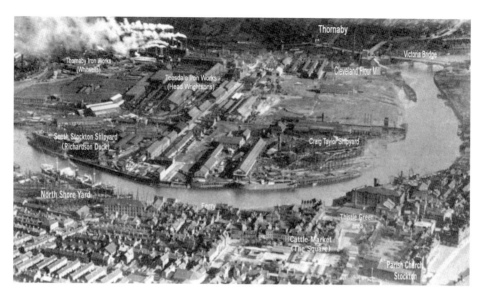

It is hard to reconcile the heavy industry in this aerial view of Stockton and Thornaby in around 1930 with the area as it is today. The ironworks and shipyards shown here employed up to 5,000 people and names of works like Craig Taylors, Richardson Ducks and Whitwells were familiar to every household. Thistle Green, close to the lower edge of the photograph, was a fashionable residence in the eighteenth century, but by the 1920s it was a slum area in the process of being cleared. The northern end of the High Street, close to Stockton parish church, is also visible.

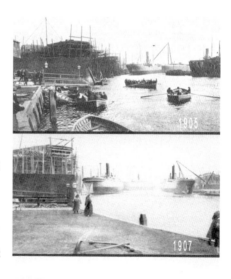

The top two images show the site of Kelly's Ferry, which operated from an inlet close to Thistle Green across to the end of Trafalgar Street at Thornaby. The ferry is best remembered for ferrying workers from Stockton to the iron foundries and shipyards at Thornaby. Two landing stages were used at Stockton (for low and high tide) but a long set of steps served both tides at Thornaby. A brush was used to clean away silt left by the receding water but it was not unknown for a hurrying worker to slip and fall in the river! The crossing was often described as 'nerve-racking' as boats carried up to sixty men, bringing the water level to just below the edge of the boat. When industry at Thornaby declined, so too did the ferry. The lower image shows the site in 1989, the shipyards and Kelly's Ferry a distant memory.

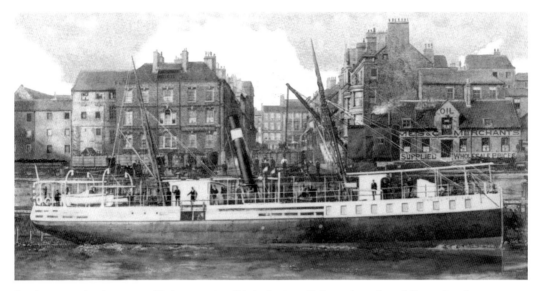

Stockton remained a reasonably busy port well into the twentieth century. One of the main wharves was Corporation Wharf, shown here in around 1906. The ship *Manoela Victoriano* is at its mooring with Finkle Street, leading to the High Street behind. One of Stockton's best known quayside buildings, the Custom House Hotel, and the warehouse premises of Raimes and Co., oil and paint merchants, are also visible.

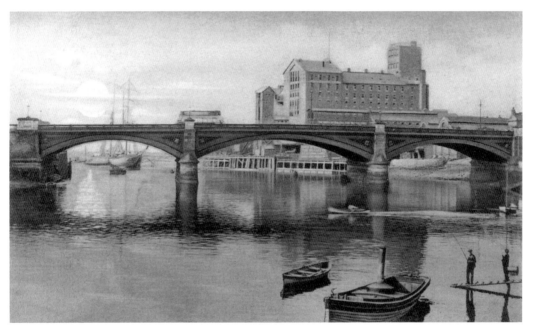

The increasing traffic using Stockton Bridge during the nineteenth century eventually led to it being replaced in 1887 by the Victoria Bridge. Costing £85,500, the new structure was much wider than the old bridge so that it could handle the increased traffic. This image shows the bridge from the south, with the premises of the Cleveland Flour Mill Ltd (known as the 'Clevo Flour Mill') visible beyond the bridge.

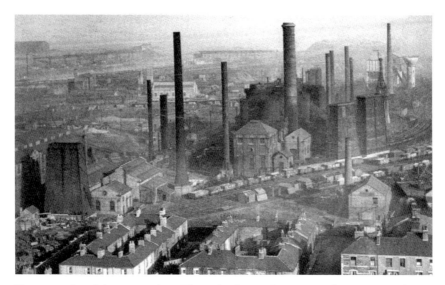

Two examples of the ironworks at Thornaby during the nineteenth century can be seen here: the Teesdale Engineering Works (later Head Wrightson) and Thornaby Ironworks (later Whitwell & Co.). Both became established in the mid-nineteenth century as part of the vast number of ironworks that opened from this time along the south bank of the Tees. By 1897 Whitwell's had over 1,000 employees and an output of over 125,000 tons of pig iron.

Nowhere was the growth of the iron industry more evident than between Middlesbrough and Newport. Although Bolckow and Vaughan established a small iron foundry in Vulcan Street, Middlesbrough, in 1841, it was 1851 before Teesside's first blast furnace was built following the discovery of substantial deposits of iron ore. The continued demand for iron led to a number of blast furnaces being built on reclaimed marshland between Newport and the old town, the area being aptly named the 'Ironmasters' District'. Far and wide, Middlesbrough became known as an 'iron town'; both the industry and the town grew rapidly: by 1901 Middlesbrough had a population of 90,000 and Teesside accounted for a third of the country's iron output. Despite depressions in the industry, local innovation helped to maintain momentum, exemplified in the 1870s by the opening of the first Bessemer Steel plant in Middlesbrough to meet the growing demand. (Reproduced from the 1897 Ordnance Survey, Six Inch series, with the kind permission of the Ordnance Survey)

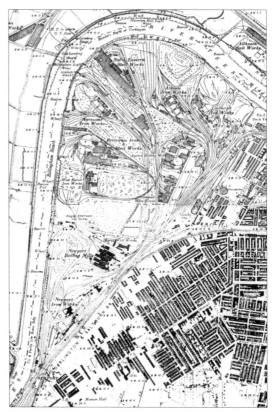

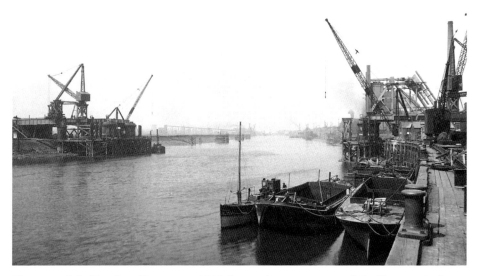

This view of the Tees from Newport in 1932 during the construction of the Newport Bridge clearly shows the extent of industry around the lower reaches of the river – a time when the skyline was dominated by ironworks and shipyards. In the foreground is the Ironmasters' District and in the distance are the shipyards at Haverton Hill.

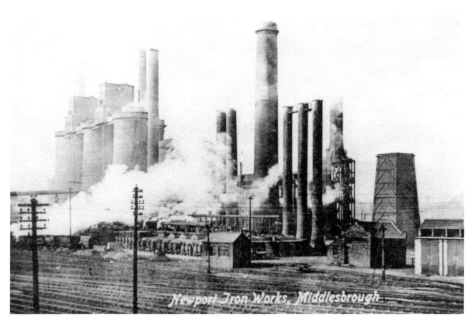

Newport Ironworks, shown here in around 1912, were founded in 1864 when Bernard Samuelson began calcining ironstone. In 1871 there were already seven blast furnaces operating at the works, the resultant smoke and grime pouring out over the adjacent area of housing. Newport Ironworks, like many others, were finally taken over by Dorman Long in 1917 and eventually closed in 1930.

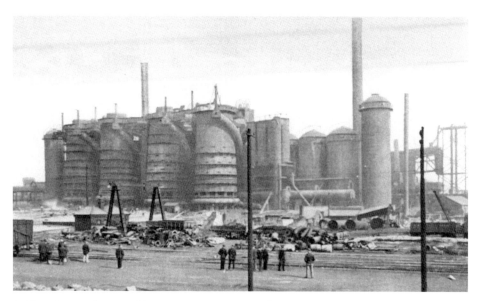

Acklam Ironworks, owned by Stevenson, Jacques and Co., were situated in the northern area of the Ironmasters' District next to the Linthorpe Works. These two works were close to the old town of Middlesbrough and across the river from the Bell Brothers Ironworks at Port Clarence. This view of the blast furnaces at the works in around 1912 shows how large they were compared with the men in the foreground.

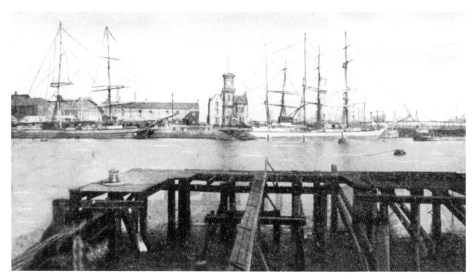

Several sailing vessels are berthed in front of the Clock Tower in around 1908, with a row of terraced houses along Dock Street also visible. Middlesbrough Dock was built on marshland east of the original town, when it was realised that an enclosed dock with a constant water level would overcome the problems of silting-up caused by the coal staiths at Port Darlington. Designed by Sir William Cubitt, the dock opened on 12 May 1842. Ten coal drops were served by a fan of railway lines from the Dock Branch, an extension of the line into Port Darlington. When the dock opened the enclosed water area was 3.6 hectares, but further extensions in 1869, 1886 and 1902 expanded this to 10.1 hectares and 2,134 metres of quayage.

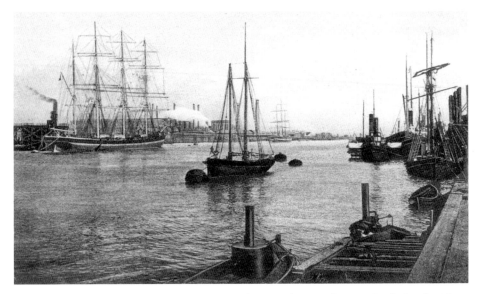

A view looking across to Port Clarence in around 1907, showing the river banks lined with industry as far as the eye can see. Several masted ships are visible, including the four-masted vessel berthed at the staithes at Port Clarence. The distant chimneys are the Bell Brothers Ironworks. This view is taken close to the point where the Transporter Bridge would later be built.

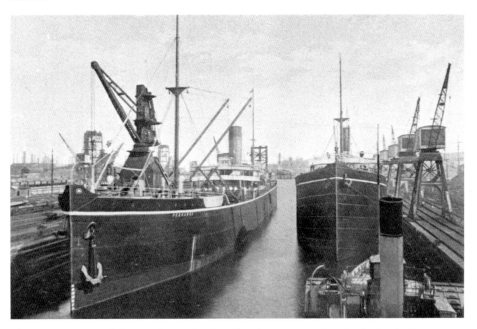

The increasing size of ships and a need to handle other cargoes after the decline in the shipment of coal led to several changes in Middlesbrough Dock. By 1902 new quays had been built and two ships are berthed here at one of the new quays in 1912. Behind them is the swing bridge across the dock entrance, and alongside the ships further evidence of refurbishment of the dock is visible, including the installation of more cranes to increase the capacity for loading and unloading cargoes.

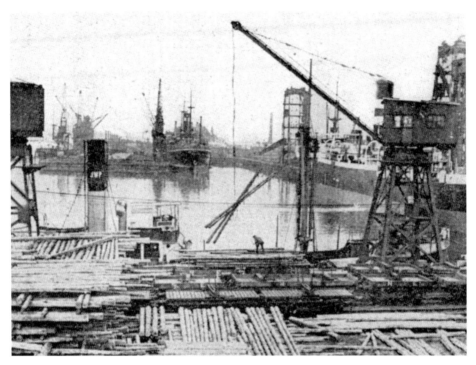

A variety of cargoes were brought into Middlesbrough Dock. This image from 16 June 1934 shows a consignment of Norwegian timber props for use in the ironstone mines at Eston.

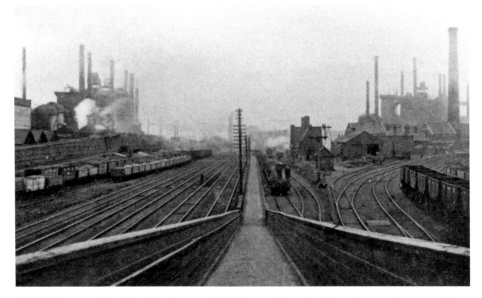

The Bolckow and Vaughan Works near Middlesbrough is certainly an impressive scene with smoke pouring out from numerous chimneys, trains pulling wagons laden with coal, and other wagons awaiting the disgorgement of their loads. Bolckow and Vaughan had several iron foundries along the riverside and these unidentified works are probably at South Bank.

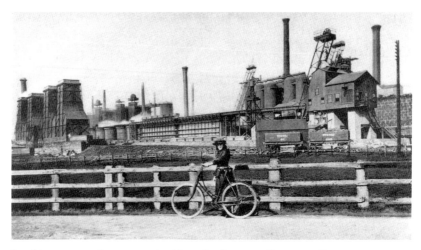

Local iron companies competed with each other as well as struggling to overcome the variable market conditions. This meant that constant improvement of the works was critical to success. When Baron Furness gained a controlling interest in the Cargo Fleet Iron Company in 1900, he demolished the old furnaces to erect the first integrated iron and steel plant in the area. It is probable that these are the new furnaces at Cargo Fleet in around 1907. Incidentally, a girl posing with her bike often featured on the photographs taken by Brittain and Wright.

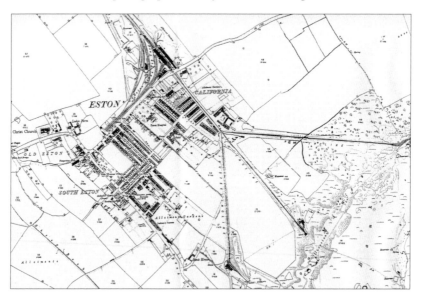

This map of Eston in around 1897 shows the location of the ironstone mines – these were operated by Bolckow and Vaughan from 1851 to 1929 and by Dorman Long from 1929 to 1949. Old Eston is also shown west of the new community established by the miners. The new settlement, Eston, was close to where the three inclines converged. 'California' – the name given to part of the new community – is also shown, as is Eston Hospital and the railway network that ran alongside Eston High Street. South Eston was the name given to houses which were built on land between the two settlements. (Reproduced from the 1897 Ordnance Survey, Six Inch series, with the kind permission of the Ordnance Survey).

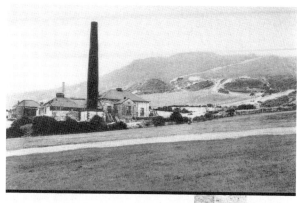

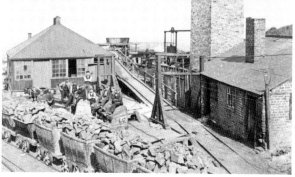

The three inclines shown on the previous map, Old Bank, New Bank and Trustee, converged at Low Drum, named after the brake drum used to control wagons descending to the Tip-Yard just to the north of Eston High Street. The considerable number of horses used in the mines were given shelter east of Low Drum stables. The top image shows this area with Eston Nab in the distance, while the lower image shows Old Bank, where the ore was first extracted by means of quarrying with a group of miners and tubs loaded with rock, also visible.

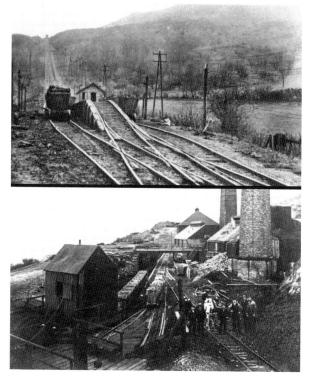

As the initial seam of ore ran out it was replaced by drift mining into the horizontal seam. New Bank was established in 1856 and Trustee soon after. Mining was by the pillar and bord method. The drift entrance was at the top of the bank and when the horses brought out the loaded tubs, the contents were sent down the incline controlled by a steel rope over the winding drum and connected to empty wagons being pulled up the incline. This process can be seen in these photographs of the New Bank incline.

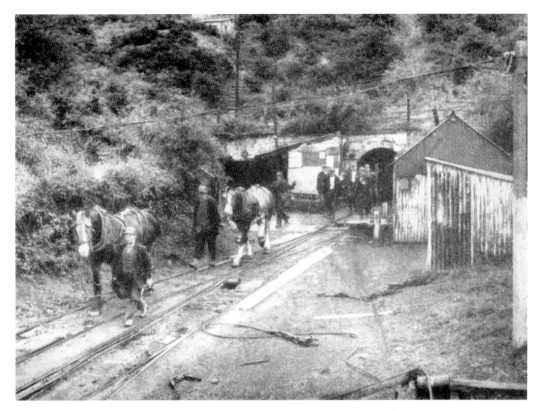

The last shift of men and horses leave the Trustee Drift entrance on 16 September 1949. Mining had gone on for ninety-nine years and the closure of Eston mines was the end of an era for the men and the community they lived in. The original development of the mines by Bolckow and Vaughan had been influential in changing Eston and the lower reaches of the Tees forever. The empty mines would stand as a monument to their endeavours.

4

URBAN GLORIES

The rise of the urban communities in the Victorian era is well documented. Cleveland played its own part in this phenomenon with towns like Middlesbrough a tribute to the Victorian entrepreneurial spirit …

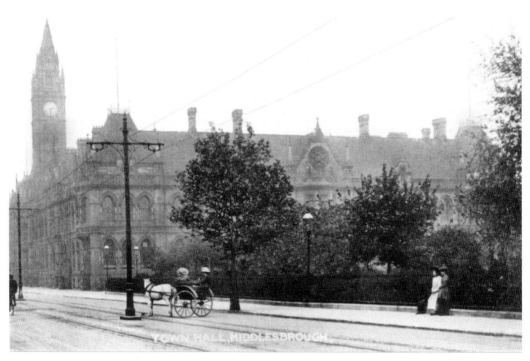

Middlesbrough Town Hall encapsulates perfectly the era in which it was built; a magnificent building, ornate and elegant, yet, in the opinion of some, more a reflection of the confidence of the Victorians rather than their taste. Opened on 23 January 1889 by the Prince and Princess of Wales, the Town Hall is an iconic building familiar to several generations.

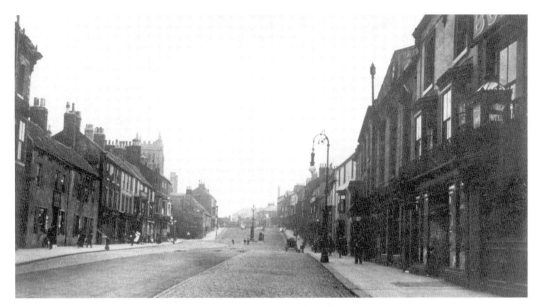

The High Street in Hartlepool is seen here around 1906. Although the town was to some extent living in the shadow of its neighbour, West Hartlepool, it nevertheless has a long history with the High Street and the markets regularly held there a central feature for many years. Today much of this housing has now disappeared. One familiar landmark still standing is St Hilda's Church, whose church tower can be seen in the distance.

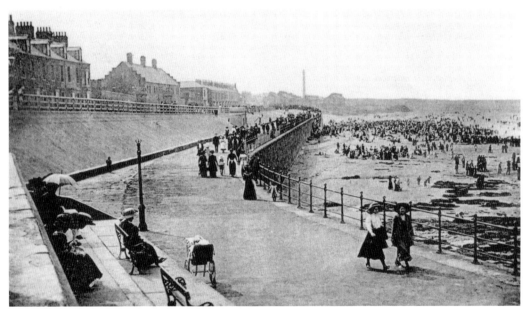

Although the commercial development of Hartlepool was overshadowed in the nineteenth century by its neighbour West Hartlepool, the old town developed a reputation as a 'healthy holiday resort'. Hartlepool Promenade, seen here around 1910, was originally built in 1889 as part of the town's sea defences but became popular as a place for a walk or for holding entertainments. This view shows its popularity: many people are taking in the sea air on their walk whilst others enjoy the nearby beach.

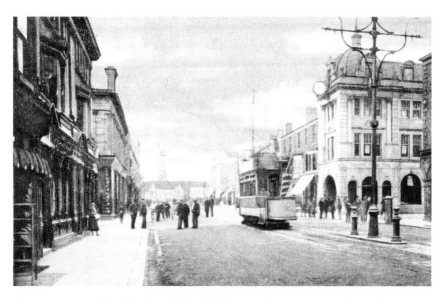

The new town of West Hartlepool, like Middlesbrough, was created alongside an industrial development – in this case new dock facilities. Increasingly frustrated with the restrictions on business at the Victoria Dock in Hartlepool, Ralph Ward Jackson formed the West Hartlepool Dock Company which built the West Hartlepool Harbour and Coal Dock south-west of the old town, opening on 1 June 1847. Rivalry between the two towns was strong from the start. The new town soon overshadowed its ancient neighbour and by 1881 the population of West Hartlepool was 28,000 compared with 12,361 at Hartlepool. Church Street, West Hartlepool, a splendid broad thoroughfare seen here in around 1906, was a popular part of the town. The Athenaeum on the corner of Lyn Street is just visible opposite the elegant premises of the Yorkshire Penny Bank. Christ Church, built in 1854, is in the distance with the statue of Ralph Jackson in front.

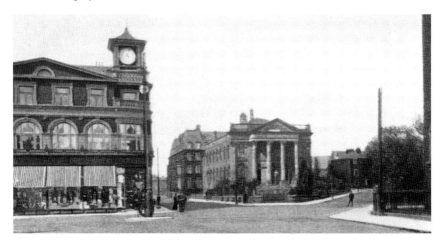

West Hartlepool's Wesleyan Chapel, seen here in around 1906, was built in 1873 in Victoria Road. An attractive structure with graceful classic-style columns, the chapel stands close to another well-known building, the Grand Hotel, owned by the London & North Eastern Railway Co. Opposite is the Gray Peverell & Co. Ltd store, later Binns Department Store, once a popular venue for shoppers.

The rapid expansion of Synthetic Ammonia and Nitrates Ltd was the catalyst behind the growth of Billingham. All around Billingham Green, as the old roads were improved, new ones were built and the desperate need for housing was addressed. Billingham Urban District Council minutes for 1927–8 reflect this growth around Mill Lane with a large number of plans for commercial development being approved. In 1928 a 'fine new shopping centre [was] ... being built to cope with the demands of an ever growing population' and by December 1928 it was reported that 'between twenty to thirty brightly decorated shop windows stood where ... there was not a single establishment six months ago.' The image shows Mill Lane, with the newly-constructed Co-Operative building in the distance.

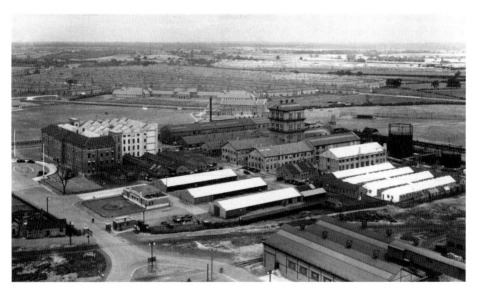

The development of Billingham is quite notable in this aerial view from the early 1930s. Hundreds of new houses built to house the new workforce at ICI can be seen stretching into the distance. In the foreground is Chilton House, the new ICI offices, which opened in 1928. Standing as it did at the gate of the factory development, it seemed to symbolise the progress achieved.

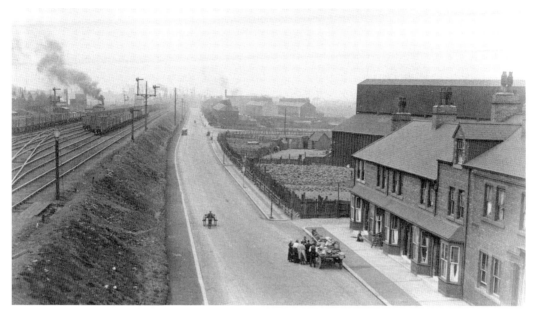

Before the nineteenth century, Haverton Hill was only a small hamlet while further downriver only a few cottages existed at Samphire Batts. The latter was renamed Port Clarence after the extension of the Clarence Railway to a new shipping point close to the site where the Bell Ironworks opened in 1854. This image shows the road from Port Clarence to Haverton Hill, with housing erected for workers opposite the railway link to Bell Ironworks. The proximity of housing and industry is notable – concerns with pollution were secondary to the need for convenient employment.

The construction of the Furness Shipyard brought many new people to the area, creating an urgent need for new housing. To meet this demand the Furness Estate was built on land close to the ancient Belasis Hall and Middle Belasis Farm. Consisting of 564 houses, this estate was known as 'Belasis Garden City'. Like those later to be built at Billingham, the houses were of a high quality and the development was regarded as a model example of its kind. This view looks to Belasis Avenue on the left and St Vincent Street on the right.

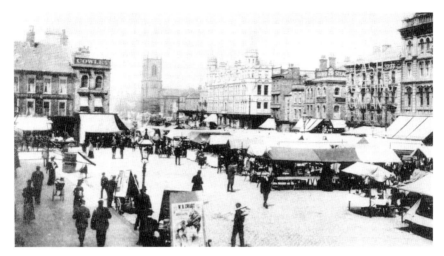

This profile of Stockton's High Street is easily recognised. The view, taken close to the start of Dovecot Street, looks north towards the parish church and the many shops and commercial buildings that existed at this time. Stockton market is in full flow, with a variety of stalls operating there on most market days, which attracted customers from a wide area. The Victoria Buildings, which replaced the old almshouses, can be seen close to the church.

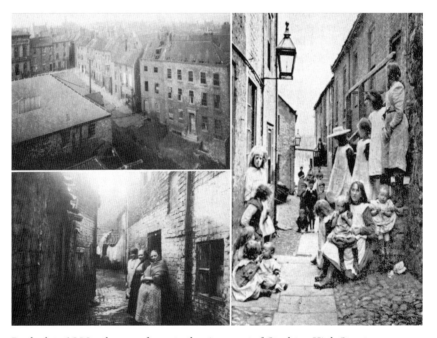

By the late 1800s, the area down to the river, east of Stockton High Street, was increasingly becoming one of squalor and misery for those living there. Thistle Green (top left), a fashionable residence in eighteenth-century Stockton, was at the heart of this rapidly declining area. Constables Yard (shown below), typifies the living conditions in many yards close to Thistle Green. Mason's Court (on the right), ran from opposite the Shambles in the High Street, down to the river. A group of children pose for the photographer, adding a poignant note to the scene.

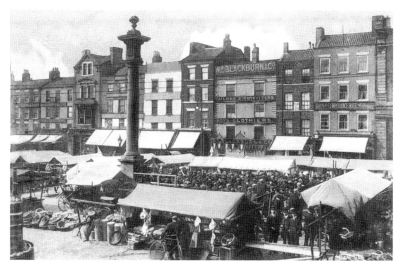

Despite many links with industry, Stockton still served a widespread farming community. One regular agricultural event was Stockton Hirings, shown here in around 1908. These took place on two Wednesdays in May and two Wednesdays in November. Farmers employed their workers here for the next six months, the agreement being sealed with a Hiring Penny. The Hirings were quite an occasion, with a fair often accompanying the event. This image shows a crowd of men around the Market Cross, surrounded by stalls from the twice-weekly market.

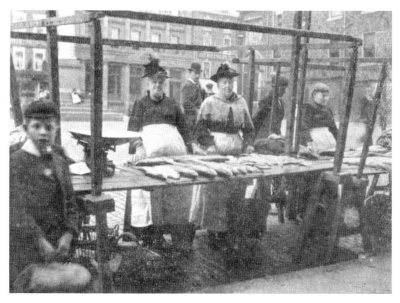

Stockton Market sold a variety of goods, including fresh food products, agricultural products and even small livestock. These ladies became something of a fixture in the Fish Market over the years, renowned for the fresh fish they sold, particularly fresh local salmon. Behind them are the Market Cross and the Town Hall, both of which are well-known landmarks on Stockton High Street.

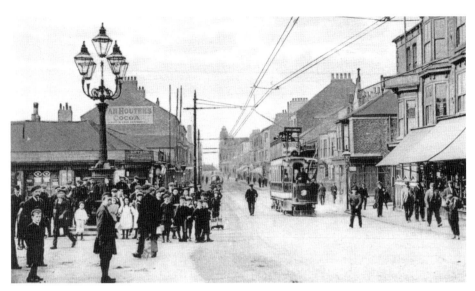

The Five Lamps, a unique five-lantern gas lamp which stood at the junction of Mandale Road and George Street, is shown here in around 1905. The lantern was a recognised landmark in Thornaby for many years, a meeting place where speeches and rallies of religious and political groups were common. The original Five Lamps were presented to the town in 1874 by three local JPs to commemorate the extension of the boundaries of South Stockton. The original gas structure was replaced by an electric lamp with five lanterns in 1950. Thornaby Town Hall is in the distance.

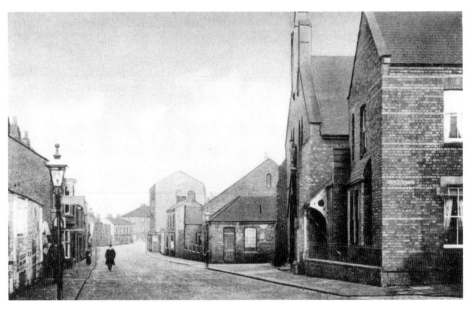

Westbury Street in Thornaby was one of the roads which converged at the Five Lamps. This image from around 1907 gives a detailed glimpse of the terraced housing commonly found here at this time. Westbury Street School and the junction with Gilmour Street are on the left while the Roman Catholic Church is in the right foreground. There were many streets like this in Thornaby at this time, with most people being employed in local heavy industry.

Yarm is seen from the north in around 1910 (top) with the Tees and Yarm Bridge visible in the foreground. In the distance is the High Street and to the left are the chimneys of the old Tannery. Wrens factory is visible in the left foreground. The town was once a prominent commercial trading centre but by the time this photograph was taken port activities were considerably reduced. The lower view shows Yarm Town Hall in around 1907. An impressive Dutch-style structure built in 1710, it reflects the economic confidence of the time when Yarm was still able to compete commercially with Stockton. By 1907, commercial activity had declined. The wide cobbled street and distant viaduct are of interest here, as is the fact that the memorial cross found next to the Town Hall today is yet to be built.

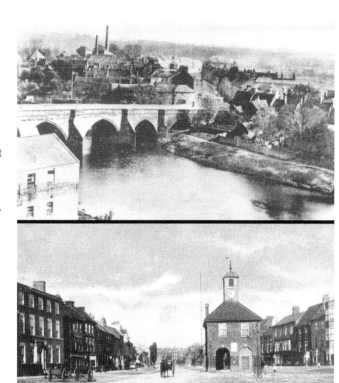

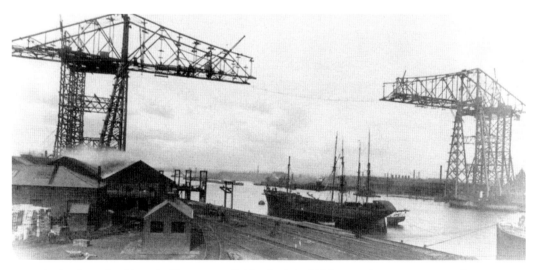

As the time of writing, the Transporter Bridge, built in 1911, nears its centenary year. For many people it remains one of Cleveland's iconic structures. Images of the completed bridge are very familiar but those of the bridge during its construction are less well known. In this photograph from around 1910, the bridge is nearing its completion.

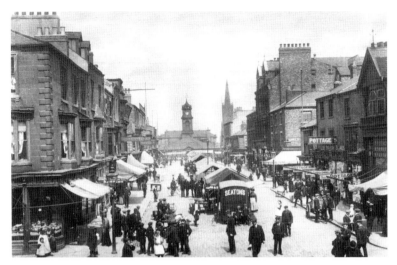

Initially, the development of Middlesbrough was confined to north of the railway, colloquially referred to as 'over the border'. The main route south from the old town, South Street, is shown here. The image from around 1908 offers a wonderfully detailed view of Edwardian Middlesbrough with its busy pavements, shops and overflow of stalls from the Market Place. Amos Hinton, one of Middlesbrough's best known shop proprietors and Mayor in 1886, was an apprentice greengrocer in South Street in 1862. In the distance the Market Hall and the first Town Hall are visible. The Foreign Money Exchange building on the corner of Henry Street reminds us of the town's role as a port. Pottage's, a popular draper's shop, is in the foreground close to the corner of Garbutt Street.

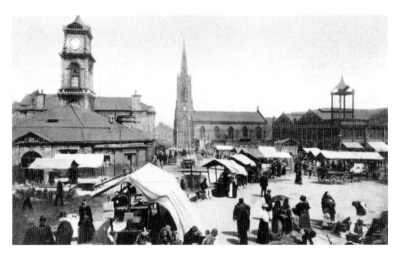

This busy market scene from around 1907 shows the Market Hall, Town Hall and, in the distance, St Hilda's Church. A dinner celebrated the opening of the first public market in Middlesbrough on 12 December 1840. The market was popular and was extended in 1856. A vegetable market opened on the corner of East Street in 1861, in the building with the unusual bell tower close to the church. On Thursday 9 October 1862, following his visit to the Bolckow and Vaughan Ironworks, W.E. Gladstone was received at the Town Hall amidst much celebration and civic pride. A Mayoral address was followed by a banquet for 200 guests in the Oddfellows Hall.

Middlesbrough was originally planned to house 5,000 people: a figure quickly exceeded, resulting in a need for new housing. Effectively hemmed in until after 1850 by the railway line to the south, Richard Otley's original grid plan of streets became choked with densely packed houses and infilling occurring on a massive scale. The upper image, St Hilda's Place, exemplifies the dark gloomy courtyards and small streets that were quickly constructed without any consideration for adequate ventilation, sewerage arrangements or water supply. A series of cholera and typhoid epidemics instigated several commissioned reports, which highlighted the need for change. This was slow to come however – it wasn't until after the First World War that any substantial rebuilding began. The demolition of St Hilda's Place, part of this slum clearance, is shown in the lower image from 23 February 1935.

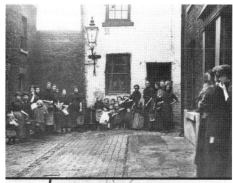

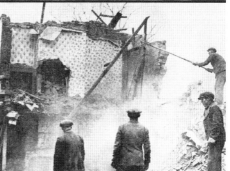

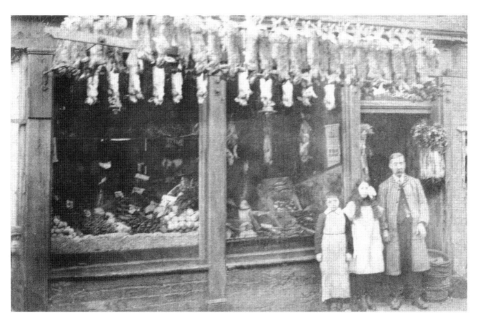

One of the most well known streets in Middlesbrough is Cannon Street. Built in the later nineteenth century as Middlesbrough extended south on land adjacent to the Ironmasters' District, Cannon Street ran parallel to Newport Road. Almost a 'community within a community', Cannon Street inspired many legends about life there and is still strongly identified in many people's minds with the tight-knit communities of old Middlesbrough. This photograph shows one of the many shops which existed there at the time.

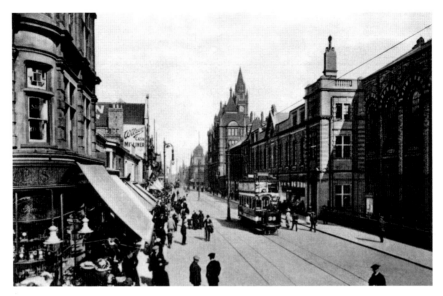

Corporation Road was one of the main roads in the development of Middlesbrough south of the railway. The view here from around 1908 is taken from close to the intersection of Corporation Road and Newport Road. A No. 36 tram passes 'Big Wesley', as the Wesleyan Chapel on Linthorpe Road was affectionately known. Close by are the Corporation Hotel, Town Hall (showing 4.05 p.m.) and the Empire Theatre. In the distance the factory chimneys are a constant reminder of the industry close by.

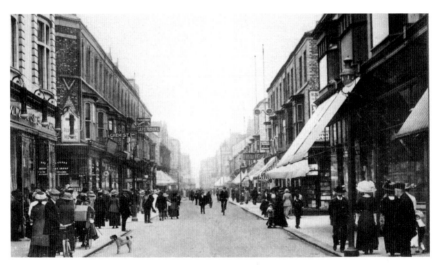

Linthorpe Road, probably one of the town's best known roads, was once a country lane to old Linthorpe. It quickly developed as a major route when Middlesbrough expanded south of the railway. The grid layout familiar in the old town is evident along Linthorpe Road as roads criss-cross almost its entire length. This view was taken in around 1910, close to the junction with Grange Road. On the left is an early Woolworth's store, on the corner of Davison Street with Red Cross House (a chemist) opposite. Further down is the Café Royal, a popular meeting place for many people in the era before the First World War. To the right is Norton Street.

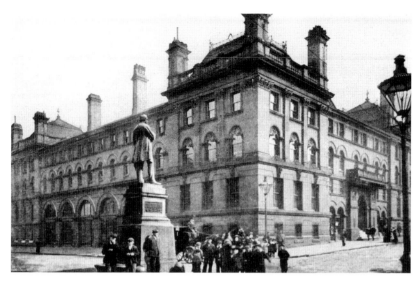

The Royal Exchange was opened by Henry Bolckow, chairman of the Middlesbrough Exchange Co., on 29 July 1868. The Exchange was a prominent part of Middlesbrough's commercial life. The Iron Market was held there every Tuesday and Friday, fixing price levels facilitating the buying and selling of iron and other commodities. The statue in the foreground is of John Vaughan, unveiled by Sir J.W. Pease on 29 September 1884. Vaughan, along with Bolckow, was important to the town's industrial development and lived in nearby Cleveland Square, before moving to Gunnergate Hall in October 1858. Vaughan died in London in 1868.

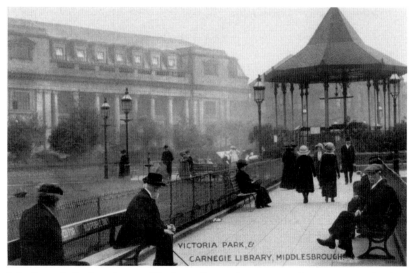

VICTORIA PARK, & CARNEGIE LIBRARY, MIDDLESBROUGH

One of the 'lungs' of Edwardian Middlesbrough was the ever popular Victoria Park. The area had originally been used as a cattle market and to host entertainments including Lord Sanger's Circus in 1889. It was decided in 1898 to develop the area as Victoria Square, complete with gardens and a bandstand. It was opened by Colonel S.A. Sadler on 12 July 1901, the proceedings being accompanied by the band of the Coldstream Guards. In the background is the Carnegie Library (now the Central Library) which opened in 1912, the building having been funded by the Andrew Carnegie Foundation.

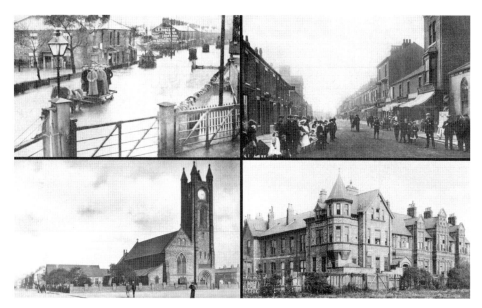

Captain J.W. Worsley and his son J.S. Pennyman were responsible for the laying out of North Ormesby, selling off land for building after 1852. In association with the owners of the Middlesbrough estate they also built a new road from Ormesby to Middlesbrough. The streets at North Ormesby were built in a grid design, centred on a market place, similar to Middlesbrough. Holy Trinity Church (lower left) was consecrated on 26 November 1869. Flooding was common, as seen in 1903 at North Ormesby Toll Bar (top left). Smeaton Street (top right) became one of North Ormesby's best known shopping areas, whilst North Ormesby Hospital (lower right), which opened on 23 May 1861, was the first purpose-built hospital in the area.

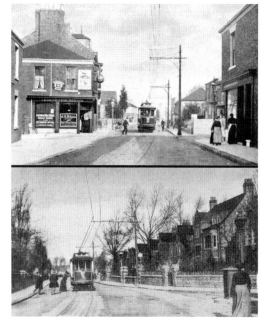

New Linthorpe (as it became known to distinguish it from the old village) was a fashionable, largely middle-class residential area popularly referred to as 'the village' by residents. There was a regular tram service to Middlesbrough, still regarded as the commercial and social centre. The top image shows a tram close to Linthorpe post office and the junction with Chipchase Road, while below another approaches the Avenue, where the route terminated. As can be seen, many residences in this area of Linthorpe were quite substantial in size. Both images date from around 1908.

Although Middlesbrough developed within a relatively short period of time, it was only after the First World War that this development began to reach areas like Acklam. This view of Acklam Road in around 1903 looks south to where the modern entrances are to Church Lane and Hall Drive. The two houses still stand today but the changes in the area close by are quite remarkable.

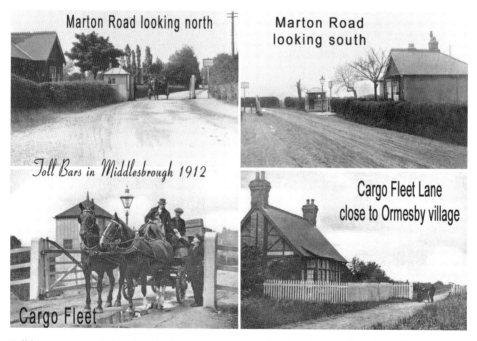

Toll bars were erected in the nineteenth century on all privately owned roads. Although some had been abolished before 1914, an Act was passed abolishing the five which remained in the Middlesbrough area from 31 July 1916. A commemorative programme accompanied the formal ceremony, bringing an end to the toll bars. Three of the toll bars abolished on that day are shown here. The toll bar cottage on Marton Road still stands nearly a century later, but is no longer on the perimeter of the town.

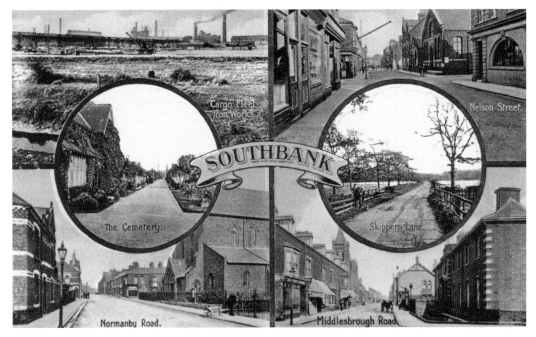

In 1855 the owners of Eston Mine, Bolckow and Vaughan, extended their works to Eston Junction, where the Eston Branch railway linked the mines to the Middlesbrough to Redcar railway. As new blast furnaces were built on reclaimed land a new settlement, Tees Tilery, was established. This settlement later became South Bank, rapidly becoming a large town. This multi-view postcard includes some familiar scenes, including one of the Cargo Fleet Ironworks, where many local men were employed.

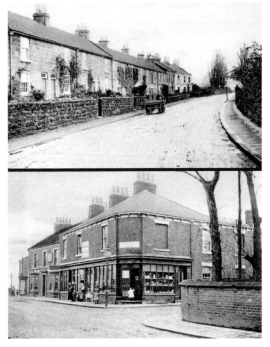

Normanby and neighbouring Eston were small but distinct villages before mining began in the Eston Hills. Although the new mines brought employment for men from Normanby and some new terraced housing close to the High Street, residents of the village recall that changes to the village were few until well into the twentieth century. These two views from around 1908 are from a similar viewpoint close to the junction of the High Street and West Street. The top image looks west towards the Poverina public house and the railway bridge, while the lower image looks east towards the junction with Cleveland Street.

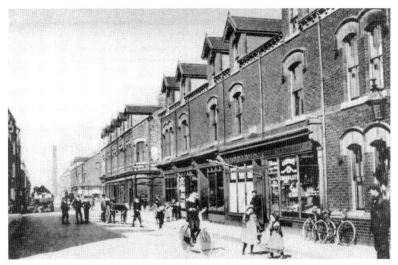

The growth of Grangetown is well documented elsewhere but it would be impossible to look at this area of 'iron and steel works' without reference to the town. Grangetown, like South Bank, is a settlement which owes its existence to the rise of local industry. Developing close to the Eston Branch railway and a nearby ironworks established by Bolckow and Vaughan, Grangetown had a very distinct identity of its own. This view from around 1909 shows a busy scene in Whitworth Road looking north, with Grayson's shop on the right and a factory chimney visible on the distant skyline.

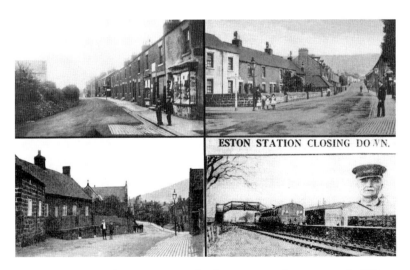

ESTON STATION CLOSING DOWN.

Many miners coming to work at Eston mines lived in a new settlement east of old Eston village. The land between the two was gradually built up and became known as South Eston. Two images from the new settlement in 1907 are featured here; top left is the High Street, later the south side of Eston Square, whilst right is Jubilee Road at the junction with the High Street and looking towards the hills. Old Eston is shown in the lower left, close to Church Lane. The final image shows Eston Station on 11 March 1929, when it closed to passenger traffic. Bob Storey, pictured, had been stationmaster since the line opened in January 1902. The NER branch line from Eston joined the former Cleveland Railway at Flatts Lane crossing and the journey to Middlesbrough took fifteen minutes.

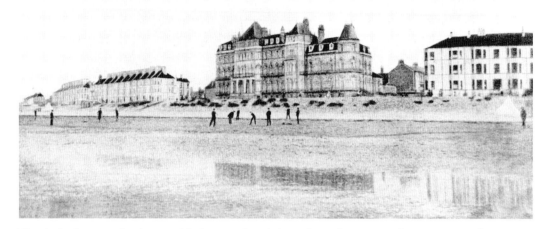

The rivalry between Coatham and Redcar continued throughout the nineteenth century as each town vied to become the leading resort. One of the developments born out of this period of rivalry was the Coatham Hotel, built in 1870. It was intended to be one of the area's largest hotels but due to a funding shortage it was never completely finished. Nevertheless, it remains an imposing building in this image from around 1920.

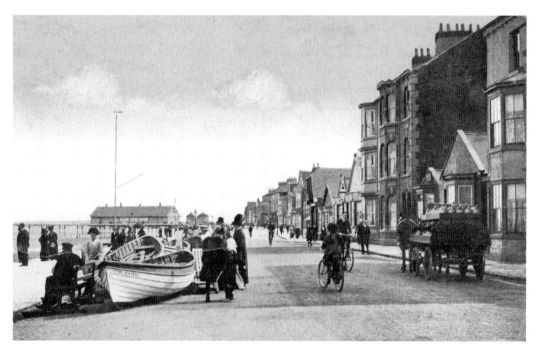

Redcar is shown here in around 1918. A small boat, the *Two Sisters*, is in the foreground and in the distance is Redcar Pier, with its familiar pavilions at the entrance. On the middle right is the lifeboat station. The pier, built by Head Wrightson in the 1870s, was 396 metres long and stood facing north to its counterpart – and arch rival – the pier at Coatham!

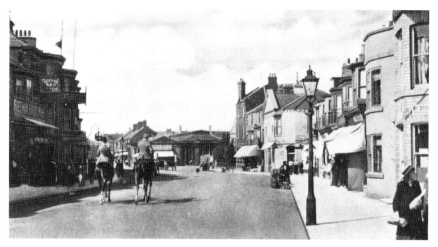

Two men on horseback ride down Redcar High Street, close to the Queen's Hotel. Throughout the later nineteenth century, Redcar not only became established as a popular resort, but also developed as a sizeable residential town as the industrial development along the south bank of the Tees brought a greater need for areas in which workers could be housed.

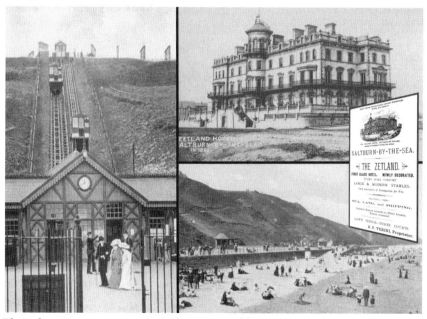

These three views capture aspects of Victorian Saltburn in around 1906: the cliff hoist, Zetland Hotel and a crowded beach. Victorian entrepreneur Henry Pease was said to have conceived the plan for modern Saltburn during a walk in the fields on the hill above the beachside hamlet, Old Saltburn. He founded the Saltburn Improvement Company when the railway from Middlesbrough was extended to the town in 1861. During the next twenty years many of Saltburn's best known features were built, including the Station Complex 1862, Valley Gardens 1862, Zetland Hotel 1863 (reputed to be the world's first purpose-built railway hotel with its own private platform), Wesleyan Chapel 1863, the Pier 1869 and Cliff Hoist 1870.

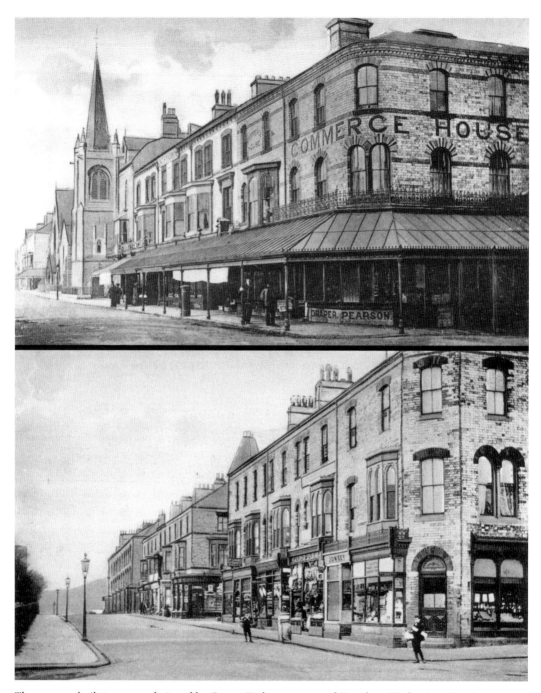

The purpose-built town was designed by George Dickenson, an architect from Darlington. Great care was taken in the planning and construction with strict rules in force to ensure uniformity in the appearance of buildings. Two roads built at that time are seen here in around 1905: Milton Street (top) and Dundas Street (below), which looks down to the Valley Gardens. The hedge and garden of the Zetland Hotel is just off to the left of the lower image.

5

TIME STANDS STILL

Although there was extensive urban development in Cleveland, there were communities and scenes which remained relatively unchanged …

Today Fairy Dell survives as part of a green-belt area amidst a large tract of housing south of Middlesbrough, but when this image was taken on 3 December 1937 it was still part of the open countryside. Fondly regarded as a local beauty spot, Fairy Dell was popular with people taking a pleasant Sunday afternoon walk.

For many years a community lived in up to thirty houseboats at Greatham Creek. This rare picture, from a newspaper feature printed on 27 August 1938, set out to explore the unusual location and interviewed the residents who lived there. Owners of the houseboats paid an annual rent of £1 to Greatham Hospital. Some had permanent addresses elsewhere; others, like 'Norfolk Charlie', lived there all year round. The *Stockton and Teesside Herald* commented favourably on the community, particularly noting the excellent condition of the boats with their 'spotless interiors'.

The Blue Bells Inn, on the road between Wolviston and Greatham, is seen here in around 1894. It is thought that the gentleman who is pouring a glass of beer close to the doorway is the landlord, John Wall. A more spacious two-storey building has replaced the one seen here.

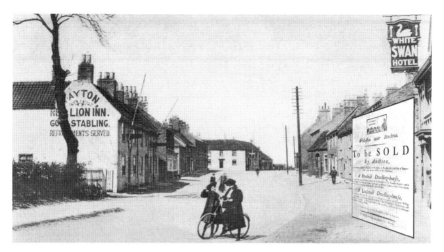

Although there was considerable physical change at nearby Billingham, change was much slower in the village of Wolviston until recent years. Thus this view of the High Street from around 1904, over a century ago, is very familiar. One major difference is that the view features four of the five public houses in Wolviston at that time: the Red Lion, Kings Arms, White Swan and Wellington Inn. While the latter still trades in the village, by 1937 the licences of the Kings Arms and the Swan Hotel had been transferred to new establishments in Billingham. The inset is a poster for an auction in Wolviston on 17 September 1799, when two 'dwelling-houses' were offered for sale.

This wonderfully evocative image of farming in the days before mechanisation shows two horses ploughing fields close to Sandy Lane, Billingham. It was taken by Leslie Dixon, a member of the Dixon family from Glebe Farm in Billingham, once the champion ploughing family in Britain. Leslie's grandfather, John, started the tradition by winning no less than seventy-eight championships whilst his father, Tom, carried on the tradition by winning 263 ploughing championships before he retired in 1932. Sons John and Leslie became the third generation to be champions, both winning national championships.

Hartburn, seen here in around 1906, was a quiet village on the road to Darlington. The cows are being walked home in the direction of the Masham Hotel, seen in the distance. Although changes have taken place in the area close to the village this scene has largely survived today, a century later, with many of the old buildings in the village still remaining, whilst new building has not been too intrusive.

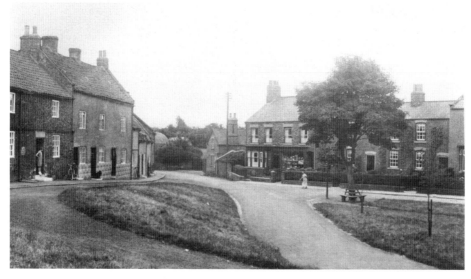

Beyond the memory of most of today's residents is the village shop that stood in the north-east corner of the Green at Egglescliffe. The shop (Pear Tree House) is seen here in the early years of the twentieth century. Close to the shop was a bootmaker, who at one time employed several apprentices. Outwardly this view across the Green a century ago bears a strong resemblance to that of today. Behind closed doors however, many residences no longer house local farm workers but those employed elsewhere, who choose to live in the fashionable commuter village.

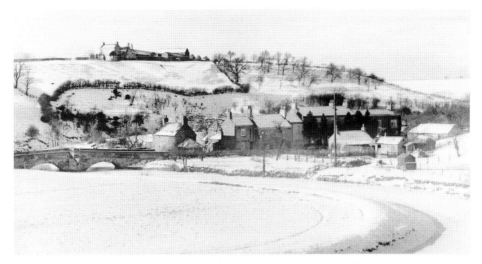

Like Egglescliffe, Leven Bridge has largely survived the many changes that have taken place around it. This wintry view from around 1910 shows the river and the Cross Keys Inn, with Mount Leven Farm perched high on the hill above – a familiar view even today. The distant hilltops are part of the land farmed by Ingleby Hill Farm – today they are the perimeter of the Ingleby Barwick housing development.

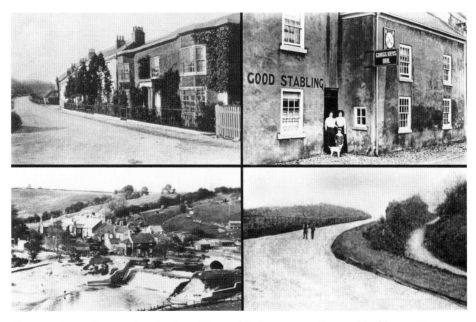

Many readers will remember the Cross Keys public house, one of several buildings at Leven Bridge. The upper images from around 1910 show the bridge as seen from the foot of Leven Bank, as well as the landlady and family standing outside the Cross Keys. The lower image on the right shows the new road at Leven Bank, which opened in April 1928, replacing the old narrow lane – shown here next to it. The lower left image depicts a general view of Leven Bridge in the early 1930s. A number of holiday chalets erected along the river bank provided accommodation for local holidaymakers during the 1930s and it became a popular destination for families from nearby towns.

Another example of a view which seems to have remained untouched by time is this row of cottages in Hilton village just south of Yarm, seen here in around 1906. A woman with her children stands in the foreground. On the left behind the hedging was Hilton Manor House, whilst to the right is the Falcon Inn (see also page 119).

These two images of Crathorne show the village at the beginning of the twentieth century. This scene is largely unchanged: the village retaining many of these buildings whilst infilling has been sympathetically done. The upper view looks north towards the Crathorne Arms, while the lower view looks south towards Crathorne post office. The inset is a notice of an auction held on 23 October 1844 in York when the Crathorne Estate, including 2,200 acres of land, a watermill, and thirty-five cottages in the village, was up for sale.

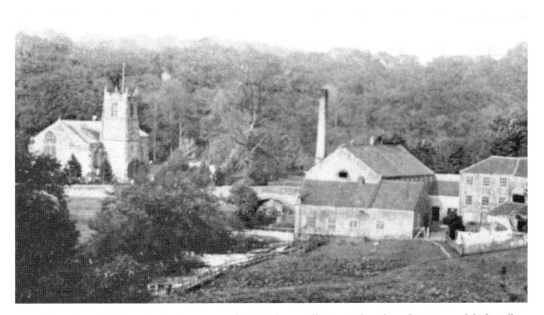

This view of Hutton Rudby from around 1905 shows All Saints Church and Hutton sailcloth mill, both standing on the banks of the River Leven. The village was well known for its linen industry. A corn mill originally stood in this field before it was converted into a power-driven flax mill in 1834; sailcloth was made here from 1857 to 1908.

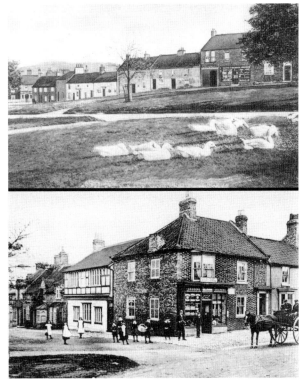

These two images show Hutton Rudby in around 1907. Hutton Rudby had at one time been two settlements divided by the River Leven. North of the river was Rudby-in-Cleveland, while Hutton lay to the south. The upper image looks across to Milburn's shop, opened by James Milburn in 1901, while the lower image is the village post office on the north side of the Green a century ago. The post office was run at this time by the Hall family and was also a grocer's, tailor's and draper's.

This peaceful rural scene is Acklam in around 1903 on the Acklam Hall Estate. The exact location is not clear, but it is suggested that the neatly clipped hedgerow on the right borders the driveway to the Hall. It is remarkable that this tranquil oasis of rural calm was so close to one of the most dynamic centres of urban growth in Victorian England.

The Devil's Bridge, Linthorpe, seen here in 1903, was also part of the belt of rural land that existed immediately south of Middlesbrough. The route over the bridge was part of a long-established pathway from the edge of the town going towards Tollesby and Marton, rural settlements dating back to pre-Norman times, but which were becoming ever closer to the nearby urban expansion.

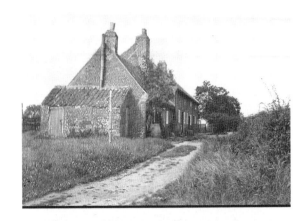

The top image shows Tollesby Cottages in around 1903, which provided accommodation for generations of farm workers. The lower image was taken on 29 August 1931 at Tollesby and shows the early use of mechanisation on a farm.

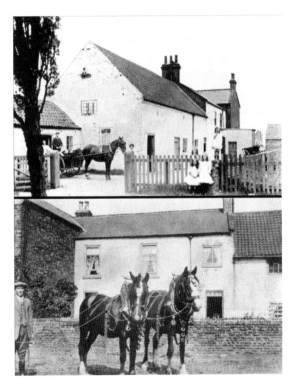

At the southern end of North Ormesby, close to where King's Road and Westbourne Grove become Ormesby Road, stood White House Farm, seen here in around 1910. Members of the Wilkinson family, who farmed there, pose for the camera in the top image and George Wilkinson proudly shows off two of his horses at the farm in the lower image. Opposite the farm were brickworks. Today even the Majestic Cinema, which was built on the land belonging to the farm and had opened on 17 December 1938, has itself been replaced by a Bingo Centre. Such is progress ...

Left top: Haggersgate Farm, part of the small rural settlement of Hemlington, was once a small settlement close to the junction of the Stokesley road and the lane from Stainton to Marton. The Dent family lived here until 1944. The top image, taken in 1931, shows farmer John Joseph Dent astride his horse, Charlie, in the paddock in front of the house. *Left middle:* Dent's daughters Barbara, aged 2, and Margaret, aged 4, stand with farm worker Fred Keiller near the farm entrance. Gunnergate Lane, the road to Marton, goes past the distant cottage which belonged to their aunt and uncle, D. and E. Walker. The family recall that during the Dunkirk evacuation, they stood waving to injured soldiers being taken in a long line of vehicles to nearby Hemlington Hospital. *Left below:* The three houses which later became The Gables public house, *c.* 1960.

Below: Berwick Hills Farm has of course given its name to the well-known housing estate in modern Middlesbrough. The last people to farm here were the Wilkinson family, who moved here from White House Farm in North Ormesby. The farm, built in the nineteenth century, was demolished in 1952 as part of the major post-war expansion of Middlesbrough Corporation's housing programme.

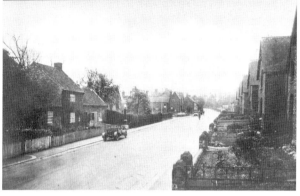

Marton is famous for its connection with James Cook, who was born here in 1728. The village is seen here in the upper image nearly two centuries later in around 1905. The Rudd's Arms is on the left foreground with housing beyond, which is still there today. This view looks north towards Middlesbrough while the lower view looks south, around 1930. It is perhaps noticeable that the village had changed very little in the twenty-five years that separates these views – it was to be the 1960s when the major changes would occur.

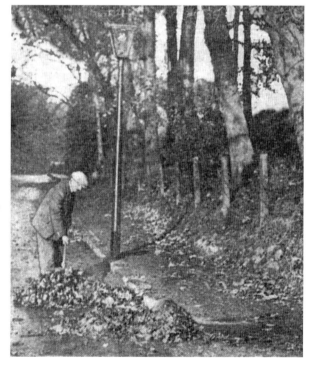

Many people have memories of Ormesby when it was still a country village. This delightful autumn scene from 21 October 1933 shows a worker as he sweeps leaves along the old road which went from Ormesby to Guisborough. This road, Church Lane, which went from the old village past Ormesby Church before taking a sharp turn to the foot of Ormesby Bank, was soon to be replaced by a new road to the east, which is still used today.

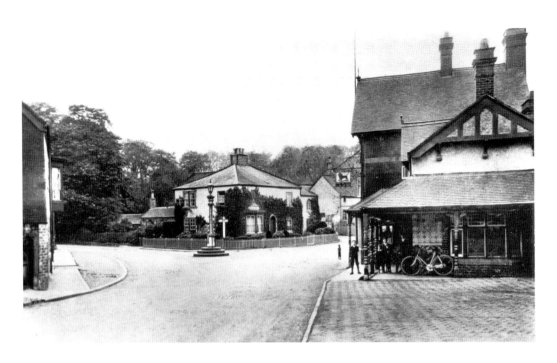

Above: This image of Ormesby is from before the First World War, showing the village centre. The old Red Lion Inn is on the right and looks towards the junction of Church Lane, the road to Guisborough and the road to Acklam.

Left: The road to Acklam is shown here in around 1900, a mile west of Ormesby where it was bridged by the railway line from Middlesbrough to Guisborough and Whitby. Off picture to the right was Ormesby station (confusingly called Marton station at one stage!). The identity of the young man gazing wistfully across the road over the fields towards Berwick Hills farm is unknown.

The upper image is a wintry view of Fairy Dell again, this time caught on film on 12 December 1937, following a snowfall. The lower image is the old village of Nunthorpe in around 1909, which was south of Nunthorpe station, where a newer settlement had been established close to the Guisbrough to Middlesbrough Railway. The entrance to Nunthorpe Hall is just visible on the right.

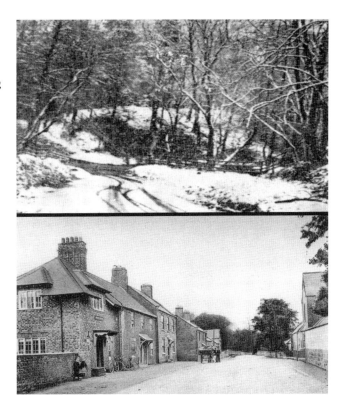

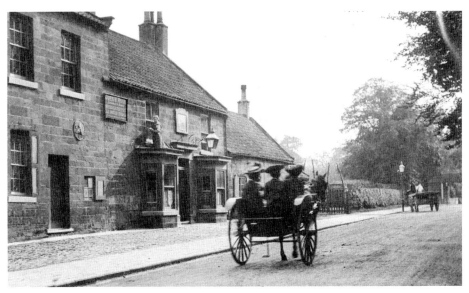

This wonderful image of life at a much more tranquil pace was taken close to The Poverina Inn in Normanby in around 1910. The Poverina Inn, shown here, was demolished in 1926 and replaced by the modern building there today. The railway bridge, which carried the Normanby branch line from Middlesbrough over the road to Ormesby, can be seen in the distance. It has been suggested that the pub was named after a horse bought by 'Squire Jackson' at York in the 1820s and which later became one of his favourite animals.

Lackenby was a community east of Eston which was lost due to the extension of the local steelworks. Also known as Low Lackenby or North Lackenby, the last residents of the community left in around 1950. This image from around 1907 shows the row of terraced properties which housed workers, most of whom were employed at the nearby steelworks.

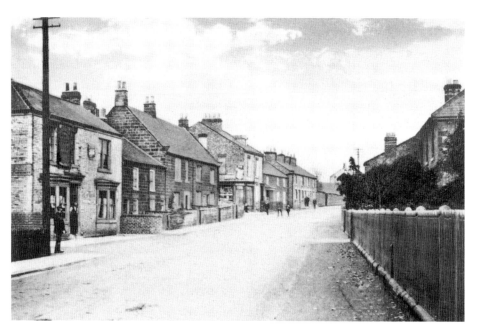

Lazenby is a village of Viking origin and featured in the Domesday Book. It remained very much a small community until the opening of the mines at nearby Eston brought rapid growth, with the population increasing from fifty-seven in 1841 to five hundred and one in 1881. Seen here in around 1910, Lazenby has managed to remain a small but distinct settlement, avoiding being absorbed by the larger communities that exist close by.

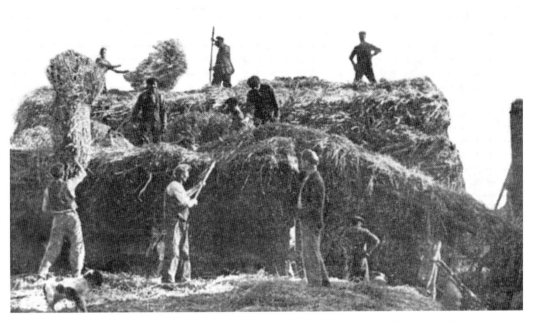

A typical rural farming scene in between the wars, taken on 5 October 1935 at Low Grange Farm, Grangetown. Once again it's quite remarkable to note the proximity of this rural scene to local heavy industry. At one time all of this area down to the river was farmland, before the industrial development which helped create the town of Grangetown itself swallowed up the land.

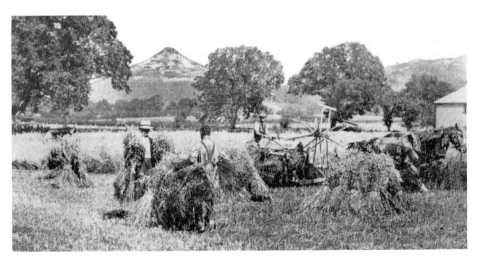

Another summer farming scene from the 1930s shows harvesting ongoing in the fields between Nunthorpe and Great Ayton, with Roseberry Topping in the distance. The image, from 4 August 1934, shows harvesting using threshing machines drawn by horses. Change came slowly to these outlying areas and horses were still widely used at this time and indeed for a good few years after the Second World War.

Marske was a very old village close to the sea. This image from around 1910 shows some of the old cottages which stood on the High Street with a group of young people standing around the lantern lamp, obviously aware of the camera taking the photograph. The village remained something of a backwater whilst communities close by developed as resorts, including Coatham, Redcar and Saltburn. However Marske has seen fairly substantial development in more recent years and has expanded far beyond the old village centre, shown here.

6

WHAT WE HAVE LOST

*Change often brings new buildings and new communities – but it can also mean
a different role for others or even their total loss …*

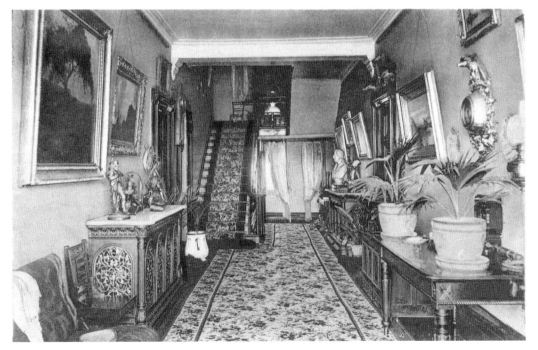

The hallway of Wolviston Hall, as seen from the front entrance, *c.* 1908. A thought to ponder on is:
where are all these objects now? Many buildings featured in the next few pages are now gone forever
and whatever your feelings about this, it is very sad that so much architectural elegance and beauty
has been allowed to disappear almost without trace. In many cases all that survives are a few faded
sepia photographs or a street name.

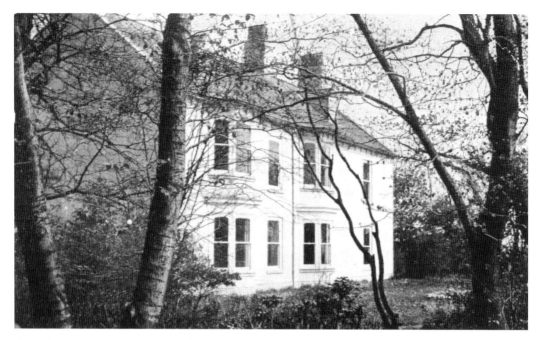

Owton Manor, shown here in around 1911, was once a substantial building but is today remembered because it has given its name to a housing estate. The area where the Manor stood has changed completely as West Hartlepool expanded southwards towards Greatham, and few now remember this fine building when it stood in open countryside – a long-gone reminiscence.

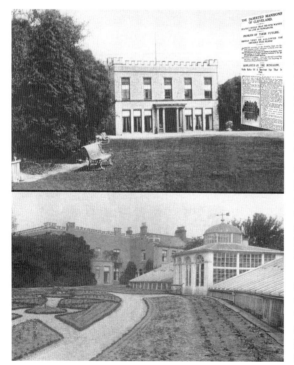

This 1928 newspaper headline, 'The Deserted Mansions of Cleveland', highlights the fact that even then many large properties were lying deserted or worse, demolished. Several buildings highlighted then are featured here. Wolviston Hall, built around 1870 and shown here in around 1906, was graceful though not extensive in size. A driveway from the Billingham road curved past glass-houses and vegetable gardens to the main entrance. Occupied first by a Captain Young, the Hall was later sold to Captain Webster in the 1880s. The Webster family remained at the Hall until 1943, when it became a Prisoner of War camp. After the war it was converted to flats but was demolished in 1964 and the land sold for the private housing development that stands there today.

Billingham Hall is Billingham's forgotten landmark. Demolished in 1935 to make way for a housing development, very few people alive today recall the building. Built in the early 1870s, three families lived at Billingham Hall before Hartlepool shipowner Charles Nielsen and his wife Margaret, with their two children, moved there on 16 April 1909. An impressive building, Billingham Hall was part of a one-and-a-half-acre site reached by a driveway from the Wolviston road. A belt of tall poplar trees stood in the grounds, ensuring privacy for the residents. The images show the Hall in around 1930, during its final days.

These images show Ragworth Hall, which was on Darlington Back Lane, close to Norton village. The upper image from around 1920 shows the Hall to the rear where beautiful tree-lined gardens were well maintained. In 1926 the Hall was purchased by the Church and was later used as a private school. The lower image from 23 February 1935 shows the converting of the stable and granary to a church. Despite later becoming rather dilapidated, the Hall survived until the 1960s. The area is now covered by housing.

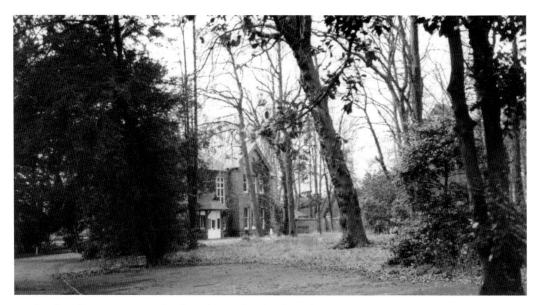

Hardwick Hall, Norton, is another large house that has been demolished and replaced by a small housing estate. This image shows the Hall in it's final days during the 1980s. It was constructed in the late 1870s and was located close to Harrowgate Lane. It eventually came into the possession of ICI and Lord Fleck, the well-known chairman of the company, lived here for a period of time.

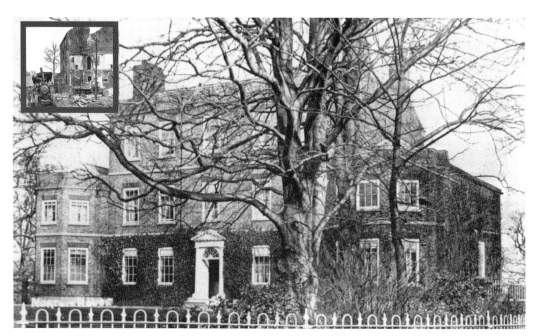

Norton House stood at the eastern end of the Green behind a tree-lined drive. A three-floored house, it was built in 1720, an impressive building often used as a meeting place by the local hunt and in the early 1800s was regarded as an important house among the social elite. Byron, Shelley, Coleridge and Wordsworth all stayed here. It was demolished in the 1930s and the inset shows the ongoing demolition of the property on 18 April 1936.

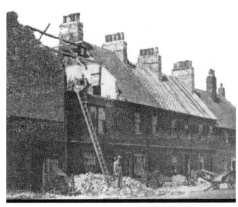

Before 1830 the Tees flowed close by Portrack and the navigation problems meant ships were often 'racked' (or towed) by either boats, men or horses from there to Stockton. Other ships would unload cargoes at Portrack to be taken by smaller ships, or across land, to Stockton. When the 'Lodge of Philanthropy', a Freemason's Lodge, moved to Portrack from London in 1756, the furniture was brought by boat and landed at Portrack. Among the buildings at Portrack were these cottages at Portrack Grange Farm, shown here on 7 May 1938. Once part of a nunnery, they contained some very fine interior plasterwork. An ivy-clad turret in the garden had been a watch-tower overlooking the Tees. The buildings have now gone – but the name of Portrack lives on.

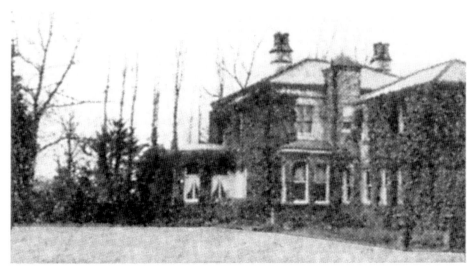

Wright, Anderson and Co., construction engineers, announced on 21 September 1929 that work would soon begin on the new aerodrome on land at Thornaby Hall. Like many of these fine buildings, the Hall was built in the late 1800s by a Victorian entrepreneur wanting to invest his self-made fortune in property. Located on Thornaby Road, south of the junction with Mill Bank Lane, the Hall was reached by a tree-lined entrance from the road. A belt of trees around the property added to the rural setting as did the scenic views of the nearby Cleveland Hills. The final owner of the Hall was the widow of Alderman J. Crosthwaite.

Four aspects of Woodside Hall, Eaglescliffe, are shown here – all are from the early 1900s except for the upper right, which is from 1934. Woodside Hall, built in 1876 by Richard Appleton from Stockton, was a very striking building with four storeys commanding an excellent view over the surrounding countryside, including the River Tees flowing towards Yarm. A conservatory overlooked extensive grounds, with lawns, exotic plants, trees, statues, fountains and other water features. Sir John Harrison, Bart., five times Mayor of Stockton, later bought the Hall, before donating it to Stockton Borough Council in 1935 to be used as a maternity home. This never came to fruition: during the war it was used by ICI and in 1945 it became part of Cleveland School. The formation of Teesside High School in 1970 led to Woodside Hall being demolished. Only the entrance towers and some aspects of the grounds survive.

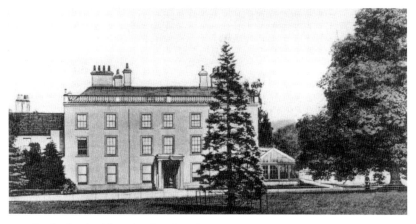

One example of a fine building that has largely survived the ravages of twentieth-century progress is the Friarage, Yarm. It has gone from being a family home to offices to a school. Built in 1770 by Edward Meynell on the site of a Dominican Friary, founded in around 1260, it remained a family home until the mid-twentieth century. The building was then used as offices by Head Wrightson and Co. for twenty years, before becoming part of Yarm Independent School. This view shows the Friarage in around 1908, while still a family home. The conservatory is no longer there and internal changes have also been made to accommodate the school.

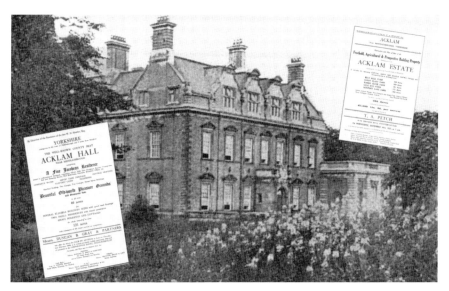

Another elegant building from the past that has survived time and became a school is Acklam Hall, now a Grade I listed building. As already noted, Acklam Hall was a fine Restoration mansion built by William Hustler in 1678. When William Hustler died in the 1920s, the Acklam Hall Estate was put up for sale. This took place on 14 December 1927, with the sale of Acklam Hall following on 2 February 1928. The insets show the sale catalogues. The Hall was acquired by Middlesbrough Corporation for £11,500 and after some modifications, opened as a grammar school for boys taking in its first pupils in September 1935. Today the building is no longer used as a school and, at the time of writing, faces an unknown future.

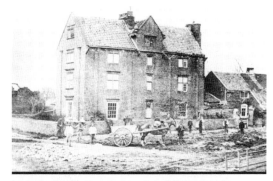

Blue Hall, Linthorpe, stood west of old Linthorpe village at the corner of Burlam Road and Roman Road. The L-shaped building with its crossed mullions and transoms of many windows was probably built in the late-seventeenth century – it features in Samuel Buck's sketchbook of 1720. Different aspects of Blue Hall are seen here in around 1865. It was demolished in 1870 and replaced by a new brick residence. In 1887 it was rented by the Salvation Army and used as a rescue-home. This appears to have lasted only until 1893, when it became again a private residence. By 1925 it was unoccupied and for sale but was eventually demolished in July 1927.

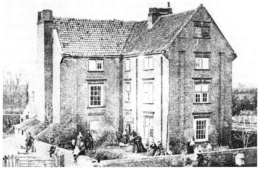

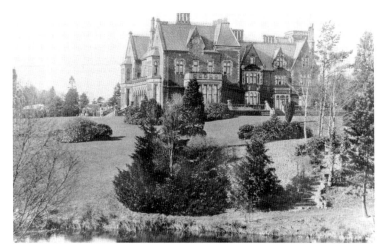

Gunnergate Hall, seen here in around 1870, was a magnificent brick house in Gothic style, built in 1857 in parkland near Marton for the Quaker banker Charles Leatham. Two years after his death in 1858 it was purchased by John Vaughan, a leading figure in Middlesbrough's iron industry along with Henry Bolckow (then living in neighbouring Marton Hall). When Vaughan died in 1868, his son Thomas took over the house and proceeded to considerably enlarge it. When Vaughan's company crashed in 1879 all work ceased, leaving a banqueting hall and ballroom unfinished. The house and contents were sold in 1881 to Henry Bolckow's nephew, Carl. The final resident of the Hall, shipbuilder Sir Raylton Dixon, purchased it in 1888 and he lived here until his death in 1901.

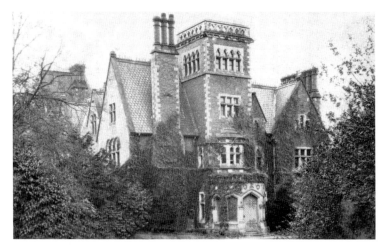

Gunnergate Hall was described in 1860 by contemporary reports as a 'salubrious residence with a fine prospect'. By 1870, under the ownership of Thomas Vaughan, the house had doubled in size. Local newspapers reported it had 'magnificent dining, drawing and billiard rooms ... including pillars of polished Aberdeen granite.' The billiard room was rumoured to have cost £40,000. Events at the Hall such as family weddings were lavish affairs, with crowds of villagers turning out to watch. When Raylton Dixon died in 1901 however, the Hall became empty as his widow went to live in Great Ayton. The Hall was never occupied again other than by troops during the First World War. The Hall was demolished in 1946, a gesture of glorious extravagance now extinguished.

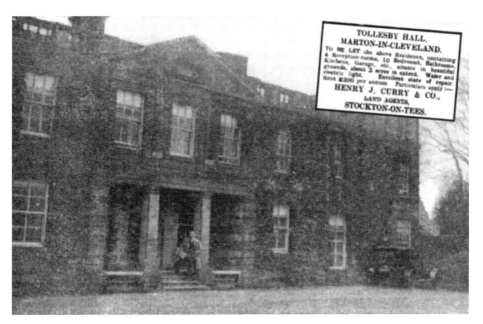

Situated close to Gunnergate Hall was Tollesby Hall. Bartholomew Rudd bought Tollesby
Estate in 1803 and replaced the seventeenth-century Hall with the building shown here
in around 1808. The Hall, which was designed with five bays with pediment, balustrade
parapets and lower two-bay wings, continued to be altered throughout the nineteenth
century. It was bought from the Rudd family by James Emerson of Easby Hall in 1886. It later
passed to his son Eleazer Biggins. The inset is an advertisement from May 1937 to let the Hall.

These rare newspaper images feature the sale, in May 1930, of the contents of Tollesby Hall,
'sold on the instructions of the late Mr E.B. Emerson,' whose father had bought it in 1886. In
1937, Tollesby Hall was for let at £200 per year, and described as 'being in good repair ... (with)
four reception rooms, ten bedrooms, bathrooms, kitchen, garage and water and electric light
both available.' After the indignity of later becoming a builder's yard, the Hall was demolished
in 1984.

Another large house south of Middlesbrough was Grey Towers. It was originally built in 1875 for William Randolph Innes Hopkins, ex-Mayor of Middlesbrough. He lived there until 1879 after which it remained unoccupied until 1895 when it was bought by Sir A.J. Dorman BT, who then lived there until his death in 1931. The building and accompanying 77 acres were then presented to Middlesbrough Corporation by Alderman Thomas Gibson Poole to be used as a sanatorium. In recent years Poole Sanatorium has closed down and been sensitively converted into modern housing.

After the death of Sir A.J. Dorman BT, the contents of Grey Towers were sold and this newspaper image features some of the goods being taken from the building on the day of the sale.

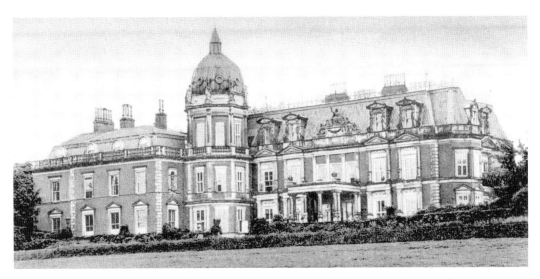

Perhaps the most elegant and indeed magnificent example of Victorian opulence in this area was Marton Hall. The north front of Marton Hall is shown here in around 1910. Constructed for Henry Bolckow, who bought the estate in 1853 as a private residence, he moved here in 1856. He continued to improve the grandeur of the Hall and its grounds, where he planted many fine rare trees. He also amassed a fine art collection, which passed to his nephew Carl, but due to the industrial recession of 1888 it was sold in London on 5 May of that year. The elegance of the Hall was exemplified by its Carrara marble columns and staircase and many other decorative features.

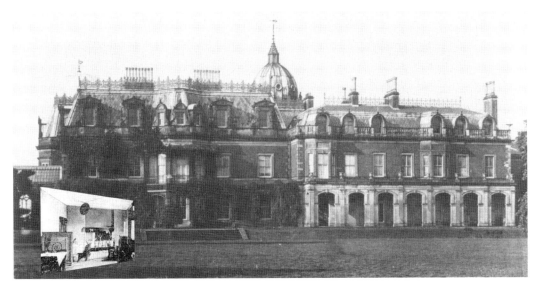

The twentieth century brought increasing financial pressures for owners of these buildings and as a result many were sold. Marton Hall, seen here from the south, was closed in 1892 and remained unoccupied for many years; much of the furniture and many of the books were sold in 1907. As happened at Gunnergate Hall, troops were stationed at Marton Hall during the First World War. The rest of the contents were sold in 1923 and it was then bought by Councillor T. Dormand Stewart and presented to the town for use as a public park. The inset, dated 31 August 1929, shows a café in what had previously been the grand dining room at the Hall.

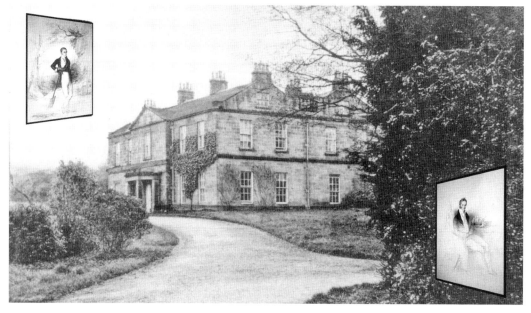

Normanby Hall, built in 1820 for William Ward Jackson, is shown here in around 1905. It still stands today in six acres of gardens and is now used as a residential home. It replaced the previous family home, 'Old Hall', where his father, Ralph Ward Jackson, lived from May 1770 until his death in 1790. William moved out of the 'Old Hall' on 30 March 1815, a move which he pondered for some time and one which he noted annually in his journal, seemingly with a sense of poignancy. Many of the plants and trees were brought to the new property from the grounds of the 'Old Hall' over the next few years. The two insets show William in 1819 aged forty-one.

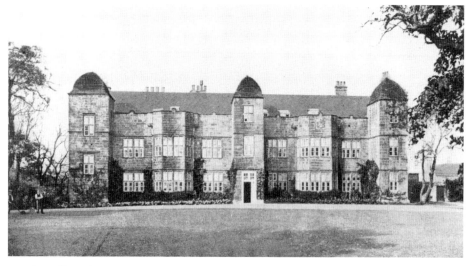

Marske Hall is a fine example of a seventeenth century former mansion house. Originally built by William Pennyman in 1625, the estate was later sold to the Lowther family in 1650 to enable Pennyman to pay a fine of £1,200 levied upon him as a result of his Royalist localities during the Civil War. The estate was later purchased by the Dundas family in 1750, becoming the home of the Marquess of Zetland. The Hall was used by the Royal Flying Corps during the First World War and was even used as a private school before eventual abandonment in 1957.

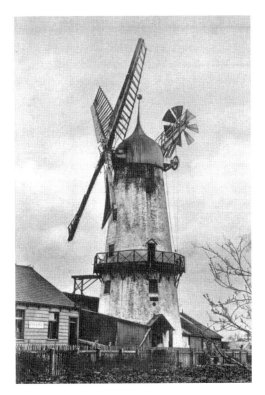

In the late-eighteenth century the troubles in France which eventually led to the French Revolution created a concern in England about securing grain supplies. As a result, a number of tower windmills were built in the Cleveland area to meet this need. After the resolution of the problems in France, most of the windmills continued to be used. Greatham Windmill, built in around 1800 and shown here in around 1907, was located on a high point north of the village where it commanded a good view of the surrounding land across to Greatham Creek. It had six storeys, four sails, a fantail of eight blades and an ogee cap roof with a tall finial. Like many others, the mill no longer stands.

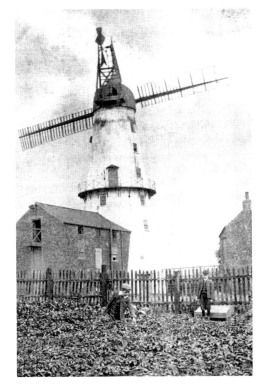

It is not known exactly when Mount Pleasant Mill, between Stockton and Norton, was built but J.K. Harrison, in his comprehensive book on milling, suggests it was pre-1824. The mill was built on high ground close to the Clarence Pottery and Mount Pleasant Farm. It was connected to the turnpike road from Stockton, and Portrack Lane, which led to the River Tees and ships which berthed at Portrack. Like the mill at Greatham, this mill was very tall, with four sails and an ogee cap roof. The site later became the Belle Vue Greyhound Stadium and eventually a housing estate in the 1970s.

Dovecot Mill in Stockton was built around 1814 at the end of Dovecot Street, where it became Mill Lane. The mill was obviously a tall structure of at least six storeys and featured a reefing gallery. Like other mills in this area, Dovecot Mill had easy access to ships berthed on the River Tees. The mill in Dovecot Street was finally demolished in the early 1930s.

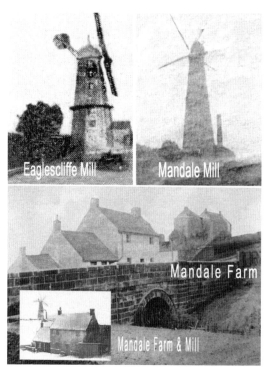

Eaglescliffe Mill

Mandale Mill

Mandale Farm

Mandale Farm & Mill

Very few images exist of the two mills featured here. Eaglescliffe Corn Mill, seen here on 20 February 1929, was located on the road to Darlington at Eaglescliffe Grange Farm. Similar in design to other local mills, it was a tall structure with an ogee cap roof and a reefing gallery and was said to be the last windmill in the district to manufacture the old-fashioned stone flour. These rare images of Mandale are thought to be from the 1860s, hence the lack of clarity. Reflecting the design of other local mills, Mandale Mill was built around 1800 on Lord Harewood's estate on land overlooking the River Tees at the Mandale loop. The lower images show the elevated location of the mill on high ground beyond Mandale Farm and Mandale Bridge, which stood on the old road from Stockton to Guisborough.

Two cuts were made to the Tees to isolate the Portrack and Mandale loops and thus shorten the distance by river to Stockton. When the cut at Mandale opened on 18 September 1810, it diverted the river but left Mandale without direct access to the river and the ships that used it. Lord Harewood received £2,000 compensation for this loss of trade. The granaries used at

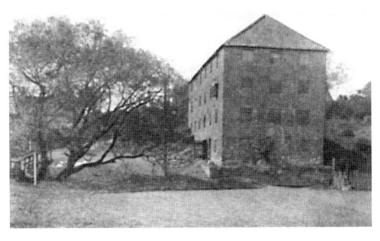

Mandale Mill are shown here in 1912, almost a century later. When a further cut to the river was made at Portrack in 1830, the course of the Tees had completely altered and in just two decades the landscape had changed forever. This was true in administration terms too as the Mandale loop was now part of the North Riding of Yorkshire, rather than being the boundary with Durham.

These two mills at Sober Hall and High Leven in Ingleby Barwick are shown here on 12 February 1930 when they were already in a state of disuse. High Leven was seven storeys high, while next to the mill at Sober Hall was a large granary. The date of construction for both mills is unknown. Harrison suggests that they were possibly built to 'exploit the needs of Stockton and possibly the new industrial town of South Stockton [Thornaby].' He also suggests that they may have failed in the face of

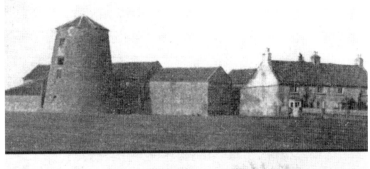

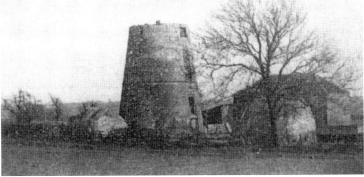

competition from newer steam mills in south Stockton. Both are still standing today despite being part of a large-scale housing development.

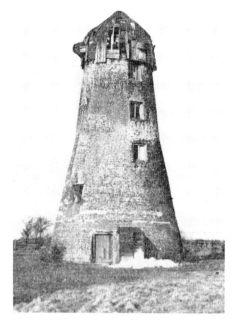

The tower windmill at Yarm was said to be one of the larger windmills in the area. Although the mill is shown here on 24 February 1931 in a state of partial disrepair, it was stated as being the 'last of the three old mills at Yarm, over 100 years old, and still standing.' There were three mills in the district, one at Eaglescliffe Grange, another on the site of the Millfield Estate in Eaglescliffe and this one in Yarm, situated on the riverbank south-west of the town.

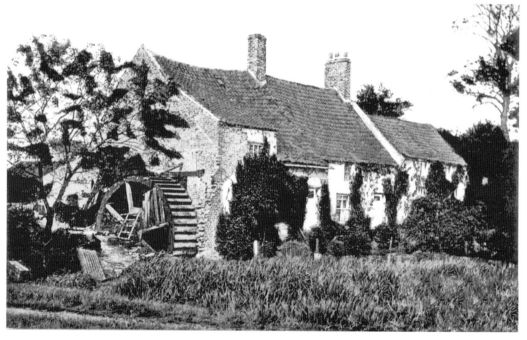

Watermills, like windmills, were a key part of the local economy for many centuries. One of the main series of water mills in Cleveland was along Billingham Beck, which flowed into the Tees at Newport. The watermill at Wolviston, shown here in 1906 when Thomas Peacock lived there, was some distance from the village itself. A mill at Wolviston is noted in Halmote Court Rolls of 1368 and 1380, when the church who owned the mill was particularly keen that villagers could only 'grind at the mills of the lord'. After many centuries of use the mill fell into disuse in the twentieth century, eventually being demolished in the 1970s.

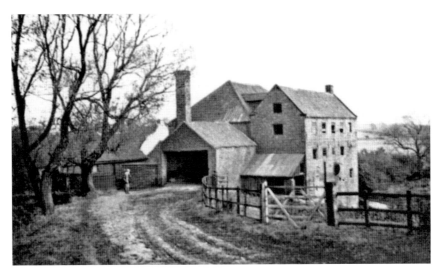

One of the largest watermills in this area was Norton Mill (mentioned in the Boldon Book in 1183), which stood on high ground west of Billingham Bottoms. An ancient pathway went across the Bottoms from the mill to Chapel Road in Billingham. This view dates from 1900 when both Norton and Wolviston Mills were owned by the Watson family. Like Wolviston however, Norton Mill also fell into decline and by 1924 was no longer in use. Extensively damaged by a bomb in 1940, the remains of the mill disappeared under the present A19 route in the 1970s.

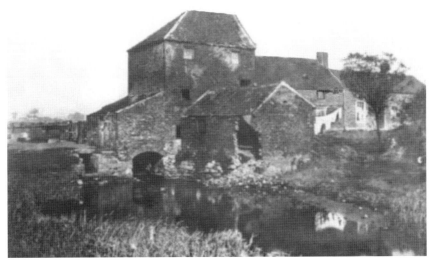

Billingham Mill, seen here in a somewhat dilapidated state in around 1900, was demolished so long ago that few people remember it today. As with Wolviston Mill, there is a mention of Billingham Mill as far back as 1368 and 1380, when villagers were told by the Halmote Court that they had to grind their corn there. Although by the seventeenth century there seems to have been some decline in the importance of the mill, it continued to be used by villagers. In fact some importance seems to have been regained as the buildings shown here date from when it was rebuilt between 1700 and 1720.

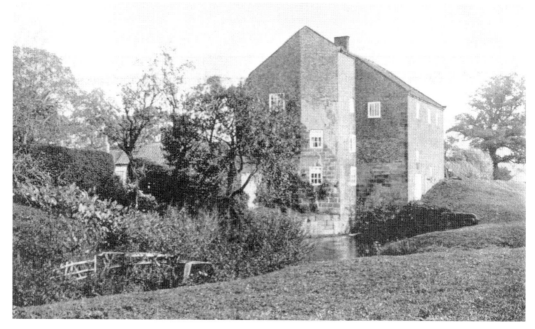

Fiddlers Mill at Stokesley is shown here in around 1909, probably on the site of a mill that was mentioned in the Domesday Book of 1086. The mill was powered by the River Leven and is within living memory of many people, having only been demolished in the 1980s.

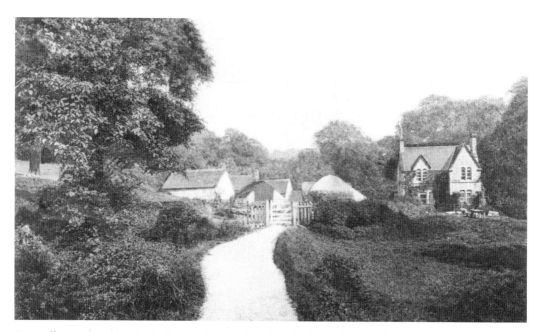

Two mills were listed at Marske in records as early as 1649, although the mill shown here dates from the early nineteenth century. In 1890 Robert Fletcher is shown as being the occupant. The mill is often referred to as 'Riftswood Mill' and stood in woodland which was inland from the coastal hamlet of Old Saltburn.

7

MEMORIES

*A potpourri of some events and entertainments that have occurred in
our area of Cleveland …*

Many older readers will remember scenes like these when each year, on 24 May, Empire Day
was celebrated with great pomp and ceremony in schools. These children are at Newport
School in 1931, marching with pride past the Union Jack. Newport School, which stood on
the corner of Anne Street and Victoria Street, opened in 1884, one of a number of schools
catering for the increasing numbers of children in Middlesbrough in the late-nineteenth
century. First celebrated on 24 May 1902, Empire Day became a national event in 1916 and
lasted until 1958, when it became Commonwealth Day.

The Prince of Wales, later King Edward VIII, paid a visit to Cleveland on 2 July 1930. He visited Middlesbrough before touring the ICI factory at Billingham. The four images show top left the Prince being greeted at Middlesbrough station by the Mayor of Middlesbrough, whilst lower left the Prince is shown touring Britannia Works after ceremonies at Ayresome Park and the opening of Constantine College. He then crossed the Tees on the steamer, *Sir Hugh Bell*, alighting at Bamlett's Wharf, Billingham. Lord Melchett, chairman of ICI, and Lord Londonderry joined the Prince on his tour of the factory and the new Synthonia Club, where he was cheered by large crowds (see the images on the right). With the official tour over, the Prince played the links course at Seaton Carew Golf Club to finish his day.

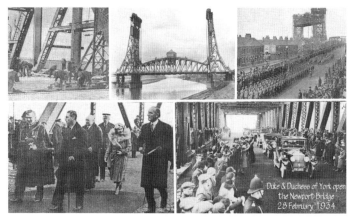

Continuing the theme of 'Royalty in Cleveland', the Duke and Duchess of York came to open Newport Bridge on 28 February 1934. The upper images show workmen finishing preparations for the visit, the completed bridge and the Durham Light Infantry marching up the approach road to the bridge to be presented to the royal party. The Duke accompanied by Alfred Cooper, Mayor of Middlesbrough, is shown lower left walking across the bridge after the civic and religious proceedings. Lower right shows the royal car travelling over the new bridge, taking the royal party back to Wynyard Park, where they were guests of the Marquess of Londonderry. This was a popular visit with large crowds throughout the day as the Prince travelled through Stockton, Thornaby, Acklam and down Linthorpe Road.

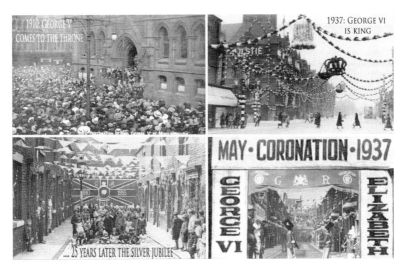

These four images feature three royal events. The images left, celebrate George V, with top, the announcement at Middlesbrough Town Hall on 6 May 1910 of his accession to the throne. The image below is twenty-five years later, showing a street party held in Grange Street, off Lower Feversham Street in Middlesbrough – part of George V's Silver Jubilee celebrations held in May 1935. The other images are from the celebrations for the coronation of his son, George VI, on 12 May 1937, with bunting across Albert Road and a lighting display around the Town Hall in Middlesbrough, and another street party celebration in Middlesbrough shown below.

A memorable visit to a fête at Ormesby Hall on 17 July 1937, by Prime Minister the Rt Hon. Neville Chamberlain (only in office since 28 May 1937) is recorded in these seven images. Top: the marquee in front of Ormesby Hall, capable of holding 3,000 people in case of rain, a large crowd, awaiting the visit and Chamberlain's arrival accompanied by Major J.B. Pennyman. In the images below Chamberlain is making his address, enjoying a fête activity, and talks to one of his hosts, Mrs Ruth Pennyman. Chamberlain chose in his address to ignore recent criticism of his appeasement policy and instead attack the evils of socialism. His speech was relayed by Uptons around the grounds, whilst the Post Office installed a special contact telephone line to Downing Street. A footnote to the visit – the Prime Minister was reported to have been very impressed with the North Ormesby Morris Dancers.

Many leading artists appeared at the numerous theatres and music halls in Cleveland. The Theatre Royal, shown here in around 1910, originally opened in Yarm Lane, Stockton, in 1866, but was rebuilt after a fire in 1906. The 1858 poster is from the Old Georgian Theatre. The other images are the Oxford Music Hall, which opened on 9 August 1867, and Empire Theatre, Middlesbrough. Many famous acts appeared at the Oxford Music Hall before it closed as a theatre in 1908. It was eventually destroyed during a bombing raid in 1940. The Empire Theatre, which opened on 13 March 1899, still survives today as a very different type of venue. Shown here in 1906, the Empire had seating for over a thousand people. Many famous stars appeared there including Charlie Chaplin, Stan Laurel, Gracie Fields, George Formby, Will Hay, W.C. Fields and Marie Lloyd. On his return in October 1937, Sir Harry Lauder paid tribute to the 'spirited nature of the audiences there.'

Another entertainment venue was Middlesbrough Town Hall. One memorable performance there was given by Rachmaninoff on 23 November 1933, when he played some of his own works as well as works by Beethoven, Schuman and Schubert. He was given rapturous applause and a standing ovation at the end of the recital. At an interview afterwards he admitted to being very pleased at the warmth shown to him by the Middlesbrough audience. A different type of entertainment was the opening of the Gaumont Cinema in Linthorpe Road on 30 March 1931. This was performed by the Mayor and Mayoress of Middlesbrough and watched by large crowds. The opening programme of films is also included.

Another two venues are the Castle Theatre in Stockton and the Opera House in Middlesbrough, both shown here in the early 1900s. The Castle Theatre opened on 31 July 1908 with a play called, 'The Lady of Lyons'. Built on the site of the old castle, the theatre replaced two late-seventeenth century cottages which previously stood on the site. Renamed the Empire in 1912, the theatre survived until demolition in the 1970s, when the Swallow Hotel was built. The Grand Opera House, built at a cost of £38,000 on the site of Swathers Carr, opened on 7 December 1903. Many famous artists came here, including Charlie Chaplin in 1912 with Fred Karno, Gracie Fields and Jack Buchanan. It closed on 21 June 1930 and reopened on 31 March as the Gaumont Cinema. The bottom image shows an advertisement for Casey's Circus, featuring Charlie Chaplin, at the Empire in 1906.

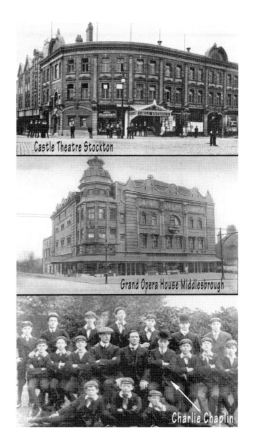

Castle Theatre Stockton

Grand Opera House Middlesbrough

Charlie Chaplin

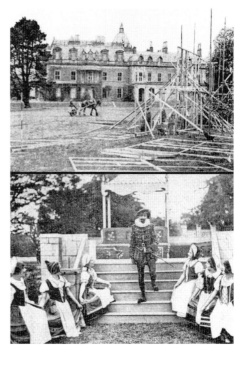

A number of different cultural events were held at Stewart's Park during the 1930s. Preparations on 12 May 1934 are shown top, for a production of 'Merrie England'. The show took place on 9 June 1934 and a scene is shown in the lower image. Events like these were a great success and attracted enthusiastic crowds, with the Hall providing a marvellous backdrop to proceedings.

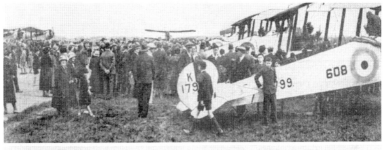

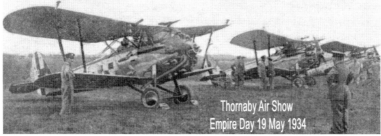

Thornaby Air Show
Empire Day 19 May 1934

As RAF Thornaby became established during the 1930s, public open days to the aerodrome were held as part of the national Empire Air Day programme. As can be imagined, these were very popular and the first of these events was held in May 1934, and attracted over 3,500 people. The aerodrome was open from 2 p.m. and refreshments were available throughout the afternoon. People could see parts of the aerodrome including the barracks, workshops and, under supervision, the hangars.

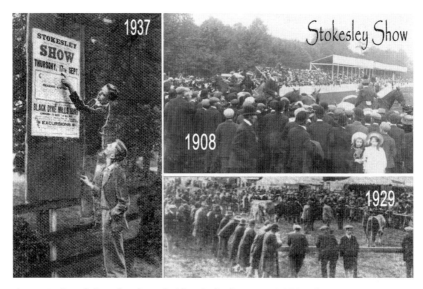

An agricultural show has been held at Stokesley since 1859, when a meeting was called at the Golden Lion Hotel on 12 March to 'establish an agricultural society with an annual show'. The show, held in September, has become one of Cleveland's leading agricultural events. These images include a show poster from 1937 and events at the show in 1908 and 1929. An annual fair continues to be held in the town and, like the show, has always proved to be a popular event.

The ninety-third Great Yorkshire Show was held from 11 to 13 July 1933, on a 100-acre field at Prissick Base – only the third time Middlesbrough had hosted the event, the other occasions being 1892 and 1906. Caricatures of some of the leading figures behind the event are shown here, as are crowds at the show watching the sheep judging. Hosting the Great Yorkshire Show proved to be a great coup for the town, especially as they won a Gold Cup for setting a new record attendance: 52,232 people, beating the previous record set at Leeds by over 3,000 people. Show Secretary A.S. Cavers said that despite an image of smoke and grime, the show at Middlesbrough had been held in one of the finest settings in its history, on a 'marvellous site … framed by nearby hills bathed in sunshine.'

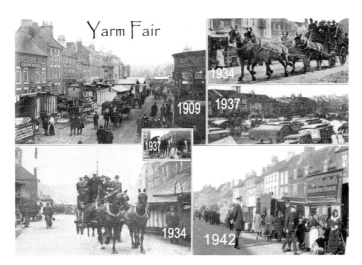

Yarm Fair, considered in the nineteenth century to be one of the largest agricultural events in the north of England, brought a great deal of trade into the town. Traditionally the first day was the horse market, followed by cattle and then on the third day, sheep and cheese. It was said that almost 500 carts came to the town for the cheese fair alone, regarded as the largest in the North-East. Sales of livestock took place in the High Street until the Second World War when, due to the increase of motor-traffic, they were removed to the cattle-mart in West Street. The number of livestock sales have declined, particularly since 1945, and today only a few traditions remain such as 'beating-of-the-bounds', shown here in 1934.

There were two main tram routes in Middlesbrough: Norton Green to North Ormesby and Transporter Bridge to Linthorpe village. Originally owned by Imperial Tramways, the system was taken over in 1921 by Middlesbrough Corporation and the Stockton and Thornaby Joint Tramway Committee. By 1929 Stockton wanted to scrap the trams but Middlesbrough didn't agree. A compromise was to withdraw the Norton service on 31 December 1931 and replace it with motor buses. It was later decided to close the route from the Transporter Bridge to Linthorpe service on 9 June 1934. Ironically, on that final day, a tram was derailed close to the railway bridge in Albert Road – as shown in this image.

On the evening of 9 June 1934 tram No.103 set off at 11 p.m. on the final journey from the Transporter Bridge. Despite no official farewell, hundreds of people turned out along the route, many crowding on to the tram as it pulled into the Linthorpe terminus for the last time – a moment captured perfectly in this image. The tram cars were sold – some went to Southend and Stockport while others went to Birmingham to be used as hen-runs. With the trams gone, the job began to dismantle the overhead equipment and workmen are shown doing this in June 1934. Ironically, one of the 'new' motor buses that replaced the much-loved trams looks on.

Stockton Cricket Club has a long history: an established cricket club is first recorded in 1816. Under the Presidency of Dr William Richardson in the mid-1840s, the club became one of the strongest in the area, hosting games against an All-England XI on six occasions between 1847 and 1859 – though it was only in 1858 that Stockton finally defeated the opposition. In 1851, John Wisden, later associated with the cricket almanacks, played for the All-England team, as recorded in the official score book. The Stockton team that won the Durham Cup in

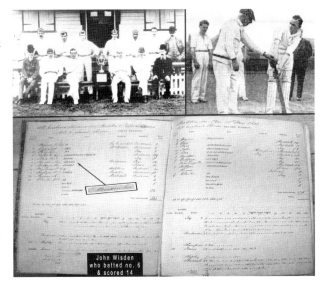

John Wisden who batted no. 6 & scored 14

1890 is shown here. Top right is George Hirst, the famous Yorkshire and England cricketer who gave a coaching session at Dorman Long's Oxford Road ground in Middlesbrough in 1934.

Another internationally famous sportsman to visit the area was a famous American golfer, Walter Hagen, who played a match against Percy Alliss, Ryder Cup player (and father of Peter Alliss, BBC TV commentator) at Eaglescliffe Golf Club on 8 July 1933. Hagen's appearance attracted large crowds to the course. Eaglescliffe Golf Club was formed in 1914 and moved to this course, designed by James Braid, in 1930.

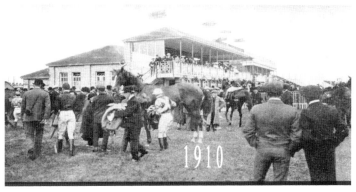

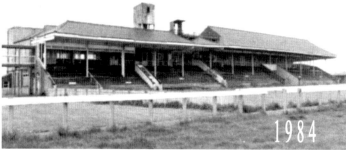

The contrasting fortunes of racing at Stockton are shown here with a race meeting from 1910 and a view from 1984, by which time the course had been sold off for commercial development. Racing at Stockton began in 1724 at Mandale Carrs (now part of the University at Stockton) and continued there until the meetings lapsed in 1816. In 1825 the meetings were revived and held at Tibbersley Farm, Billingham. In 1845 the races lapsed again only to be revived in 1855 on the course shown here at Mandale Bottoms.

Lord Londonderry is seen here with his official party on their way from Wynyard Hall to the August meeting at Stockton races in 1910. This was a lengthy procession, which attracted large crowds as it made its way down Stockton High Street before crossing over the river at the Victoria Bridge on its way to the racecourse.

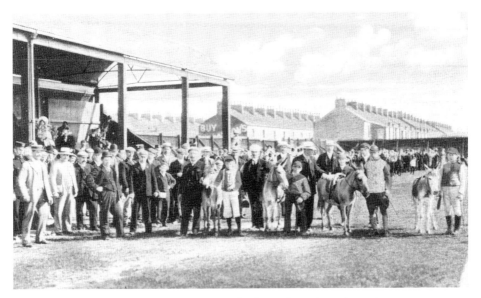

The Cherry Fair Races at Stockton, which date back to at least the eighteenth century, were held annually on 18 July. Several photographs exist of the races, this one being dated 1904. The races were held at the Victoria Football Ground, close to Oxbridge Lane, and featured donkey races as well as several other fun activities. As can be seen they attracted large crowds.

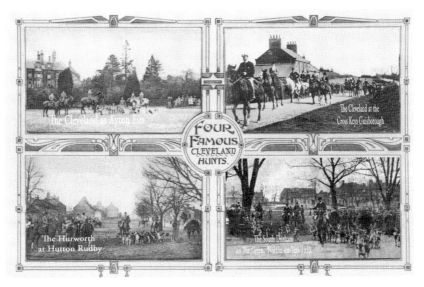

There were several hunts based in Cleveland and three are shown here in the years before 1914 and one in 1933 at Norton. Records maintained by each hunt provides much topographical detail about many areas when they were still largely agricultural land. Until the late 1820s the Cleveland Hunt always started their season in the turnip fields at Middlesbrough Farm, near to where the Transporter Bridge stands today. On 31 December 1840, over 100 riders joined a hunt through Acklam and Ayresome villages, down Linthorpe Lane (Road), across the 'new' Middlesbrough Road (Marton Road) to Cargo Fleet and back up to the Eston Hills. As the towns expanded, the area available for hunting decreased.

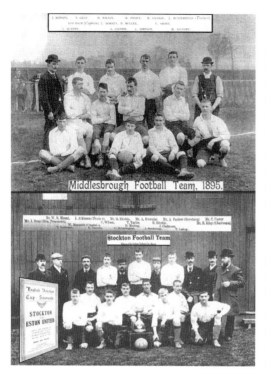

Middlesbrough Football Team, 1895.

Stockton Football Team

In the 1890s, Middlesbrough and Stockton Football Clubs were widely regarded as two of the region's strongest amateur teams. Middlesbrough are photographed here before their Northern League game with St Augustines of Darlington, whom they beat 11-0 on 20 April 1895! A week later in Leeds they won the FA Amateur Cup by beating Old Carthusians 2-1 and returned home to a hero's welcome at Middlesbrough station. At this time Boro' played at their Linthorpe Road ground close to Clifton Street, with a plantation to the west – visible in the photograph. Stockton, pictured in the same year, also had a successful season, winning the Durham Challenge Cup. Stockton won the FA Amateur Cup three times, including this win in 1912 over Eston United – the inset shows the programme for the game.

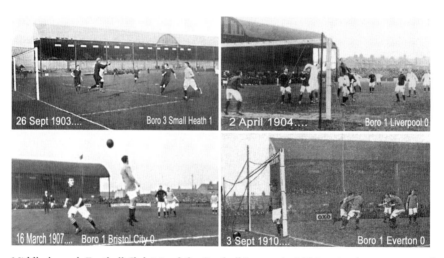

26 Sept 1903.... Boro 3 Small Heath 1

2 April 1904.... Boro 1 Liverpool 0

16 March 1907.... Boro 1 Bristol City 0

3 Sept 1910.... Boro 1 Everton 0

Middlesbrough Football Club joined the Football League in 1899, gained promotion to the First Division in 1902, and moved in 1903 to Ayresome Park – designed by Archibald Leitch, doyen of football ground designers – a momentous period for the club. The new ground officially opened on 12 September 1903 with 30,000 fans watching a First Division game against Sunderland. In the years leading up to the First World War, Middlesbrough had a strong team, finishing in their highest ever position of third in 1914. These images show scenes from those early years: the game in 1903 was the second ever game at Ayresome Park and features the legendary goalkeeper Reginald Garnett (Tim) Williamson from North Ormesby, who made 602 appearances for the club between 1901 and 1923. He was also an England international player.

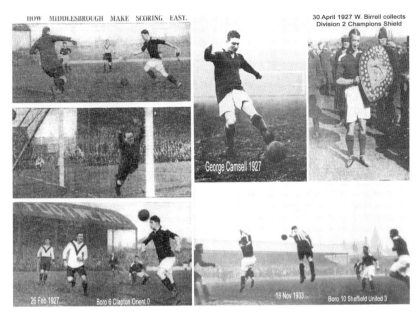

HOW MIDDLESBROUGH MAKE SCORING EASY.

30 April 1927 W. Birrell collects Division 2 Champions Shield

George Camsell 1927

26 Feb 1927.... Boro 6 Clapton Orient 0

18 Nov 1933... Boro 10 Sheffield United 3

If Williamson was a legend before the First World War, and Wilf Mannion a legendary figure after the Second World War, then George Camsell dominated the inter-war years. He was especially influential in the 1920s when Middlesbrough were involved in two relegations and promotions. Older fans will remember Camsell scoring a record 59 league goals in 1926/27 as Middlesbrough won the Division Two championship. These images include scenes from that season, including Camsell in action and Billy Birrell collecting the championship shield after defeating Reading 5-0 at Ayresome Park on 30 April 1927. Another club record is commemorated here with an image from 18 November 1933, when Middlesbrough beat Sheffield United 10-3, still their highest ever win to date. Camsell scored four goals that day.

TRAINING TELLS IN THE END

St. Peter's Win Renown in Rotherham Cup-tie

BEST WISHES. — The South Bank St. Peter's team and officials photographed early this morning before leaving South Bank station for Rotherham for their first round F.A. Cup-tie. Sitting fourth

The following week South Bank St Peters, a local amateur team, aroused a great deal of interest in Cleveland when they got through to the first round proper of the FA Cup. They were drawn away to Rotherham United, their progress being eagerly followed back in South Bank. The team gave a heroic performance to go 2-0 up at half-time. However Rotherham managed to draw level, then broke South Bank hearts by scoring the winning goal in the last minute of the game. Despite their 3-2 defeat, the team arrived home to a hero's welcome with their pride intact.

A number of establishments opened to offer refreshment to the increasing number of people taking up cycling or walking as a leisure activity at the end of the nineteenth century. Norton Bungalow, which opened in around 1900, stood on the corner of Beaconsfield Road and Billingham Road. It resembled an oriental tea room and became very popular with its regular clientele. Unfortunately, the Bungalow was burnt down in 1921, an event captured in the inset image.

Marton Bungalow

Like Norton Bungalow, Marton Bungalow was for many years a popular venue for walkers and cyclists enjoying the countryside around Marton village. The timber-built bungalow was situated opposite Stewarts Park on the corner of Ladgate Lane and can be seen from two different aspects in these images from around 1910 and then again in 1930s. Inside there were wicker chairs and tables and a veranda was also available for seating.

Ormesby Bungalow

There was a similar establishment at neighbouring Ormesby village. An Edwardian building, Ormesby Bungalow was situated close to where the existing garage stands today and, as a popular venue for dances, it was very much a part of social life in the village. A poster advertising a forthcoming dance can be seen on the lower image. Both images are from before the First World War and capture the rural location of Ormesby at that time.

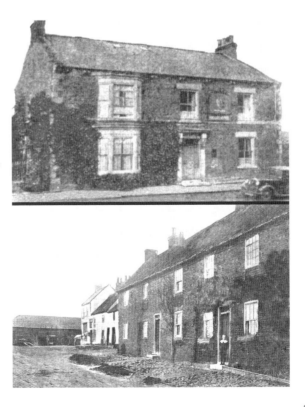

The Falcon Inn, Hilton, is shown here in 1935 when it featured in a newspaper article because the vicarage and the inn were both in the same building! In one half (the part with the ivy-covered wall) lived the vicar, the Revd C.B.D. Farrow and his family, while in the other was the licensee of the inn, J.C. Robinson, his wife and two sons. Below is the Fox Covert at High Leven in around 1908, then a small country inn with the landlord also being involved with agriculture, as was quite common at that time. In the distance can be seen the agricultural buildings that stood close by. These survived until the 1960s. Today this area is the car park.

The father of James (Captain) Cook built a cottage on Bridge Street, Great Ayton, in 1755. Following its sale in 1933 (see the sale notice in the right inset) the cottage was deconstructed by Octavious Atkinson & Sons of Harrogate, prior to being transported to Australia in 1934. Each stone was numbered so that the cottage could be rebuilt exactly in Melbourne. This image from 24 February 1934 shows some of the crates loaded up on a freight train ready for their journey. The other inset is a brochure issued in 1928 to celebrate the bicentenary of Captain Cook's birth. The cottage is still a tourist attraction today in Fitzroy Park, Melbourne.

IN THE TEES. — Bathers making the most of the present heat wave with a cooling dip in the Tees at Newport, under the shadow of the new Tees Bridge.

This group of people are swimming in the River Tees, close to the Newport Bridge, on 16 June 1934. Cleveland was experiencing a heatwave at the time, and the bathers certainly look as if they are enjoying their dip. As they cling to some of the old staithes by the riverside they seem unperturbed by the high levels of pollution that must have existed in the river at that time.

8

1937–8

*Political events across Europe made this an interesting year for the nation, including
Cleveland, in what would be the last year of normal life for some time …*

July 1937: as usual this was a month for being by the seaside. This family are having a day on the
beach at Redcar with grandparents on hand to keep order and look after the baby. The town was still
a very popular destination for people in the Cleveland area.

August 1937: for these Middlesbrough football players it was early pre-season training at Ayresome Park. From left to right: Cumming, Fenton and Birkett leaping over Cochrane, Baxter and the legendary George Camsell.

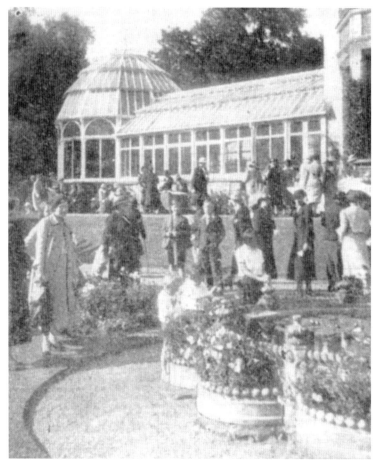

September 1937: this may well have been the month when Hitler was talking about Germany's need for *Lebensraum*, but that was of little importance to those attending Preston Parish Church garden fête held in the grounds of Woodside Hall, Eaglescliffe, on this sunny Saturday afternoon.

October 1937: as autumn approaches it was a time for farmers to prepare their land for the next year. These two horses pulling the plough are continuing a traditional approach to farming that would soon be confined to history. This is a scene on a farm near Guisborough.

November 1937: the Service of Remembrance was held annually at the Cenotaph in Middlesbrough close to the Dorman Museum and Albert Park. A large crowd attended in 1937, many conscious perhaps that there could well be more names added to the memorial in the near future.

December 1937: Christmas approaches and customers at Eaton's store on Corporation Road, Middlesbrough, place gifts on a Christmas tree in aid of North Ormesby Hospital. Despite a very cold week before Christmas Eve, trade was brisk at many shops throughout Cleveland, according to local newspaper reports.

January 1938: the ever-popular pantomime tradition sees children from Nazareth House treated to a performance of 'Aladdin' at the Empire Theatre, with a chance to meet the cast after the show.

February 1938: in Germany the Austrian Chancellor, Kurt von Schuschnigg, visits Adolf Hitler to discuss the Nazis taking a greater part in the country's affairs. In Middlesbrough the work to convert Green Lane from a country lane to a wider route, which would be part of the town, is almost complete as shown here.

March 1938: the Anschluss on 12 March sees Austria become part of Germany and causes some alarm in Britain. In Middlesbrough plans are made for the formation of the ARP and a headline in the *Evening Gazette* says that 7,000 volunteers are going to be needed. Here women members of the Stockton VAD Red Cross Detachment are wearing gas masks as they go into a gas chamber at an anti-gas demonstration at Portrack recreation ground.

May 1938: the crisis
in Europe is closer now
whilst in the Far-East,
Japan and China have
already been to war.
In Middlesbrough,
Doris Lavender is being
crowned 'May Queen' at
a ceremony at Denmark
Street girls' school.

June 1938: the ancient
midsummer procession
which had been held
every Midsummer's
Day since 1690 at
Kirkleatham Hospital
winds its way around
the quadrangle at the
hospital before the
annual church service
is held.

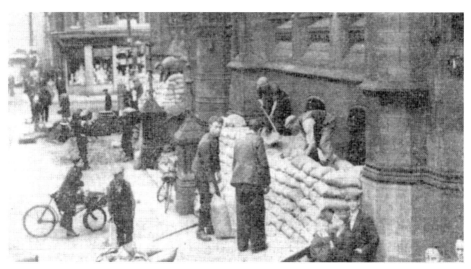

September 1938: sandbags are being laid around the Town Hall in Middlesbrough as the
Munich crisis looms ever closer. The spirit of the people of Cleveland is about to be tested
once more ...

BIBLIOGRAPHY
& SOURCES

BOOKS

Bamforth, H., et al., *Billingham Port Clarence and Haverton Hill in 1851* (Durham University, Durham, 1975)

Bass, B., *Rudds of Marton* (Earth-Net Communications, 2001)

Betteney, A., *Brickworks of the Stockton-on-Tees Area* (Tees Valley Heritage Group, Teesside, 2007)

Brewster J., History of Stockton 1829 (Jennet, 1829)

Chapman, V., *Around Billingham* (Chalford, Stroud, 1996)

Graves Revd J., *History of Cleveland* (Jollie, 1808)

Harrison, J.K., *Eight Centuries of Milling in North East Yorkshire* (North York Moors National Parks Authority, 2008)

Harrison, J.W.H., *A Survey of the Lower Tees Marshes* (publisher unknown, 1916)

Hempstead, C.A., *Cleveland Iron and Steel Industry* (British Steel 1979)

Hatton, C.H., *Haverton Hill, Port Clarence to Billingham* (Tempus, Stroud, 2005)

Horton, M., *Story of Cleveland* (Cleveland County Libraries 1979)

Lillie, W., *History of Middlesbrough* (Eyre & Spottiswood 1968)

Marchant, A., Marchant, J., *Tithe Maps of Hartness* (Christian Inheritance Trust, Yarm, 1995)

Mathews, A.D., *Acklam Hall: House and History* (1987)

Menzies, P., *Billingham in Times Past* (Countryside, Chorley, 1985)

Menzies, P., *Billingham in Times Past Vol.2* (Countryside, Chorley, 1986)

Menzies, P., *Cleveland in Times Past* (Countryside, Chorley, 1987)

Montgomery Hyde, H., *The Londonderrys: a Family Portrait* (Hamish Hamilton, 1979)

Moorsom, N., *Middlesbrough As It Was* (Hendon Publishing Co., 1983)

Moorsom, N., *Book of Middlesbrough* (Barracuda Books, 1986)

Ord, J.W., *History and Antiquities of Cleveland* (London 1846, reprinted Shotton 1982)

Race, M., *Yarm of Yesteryear*, (Yarm, 1981)

Sharp, C. Sir, *History of Hartlepool*, (Proctor, 1851)

Smith, G., *Smuggling in North Yorkshire* (Countryside Books, 1994)

Sowler, R., *Roads and Road Transport in Stockton District* (Stockton, 2008)

Sowler, T., *History of the Borough and Town of Stockton* (Teesside Museums, 1972)

Stephenson, P., *Linthorpe Road and Linthorpe Village* (Middlesbrough Reference Library, 2000)

Still, L., Southern, J., *Medieval Origins of Billingham* (Billingham Urban District Council, Billingham, 1968)

Tomlin, D.M., *Past Industry along the Tees* (A.A. Sotheran, 1980)

Tomlin, D.M., South *Bank to Eston in Times Past* (Countryside Books, 1987)

Towland, D., *The Stockton Georgian Theatre* (Stockton, 1991)

University of London, *Victoria History of the Counties of England* (Dawsons, London, 1968)

Waterson, E. and Meadows, P., *Lost Houses of County Durham* (Raines, 1989)

Waterson, E., and Meadows, P., *Lost Houses of Yorkshire and the North Riding* (Raines, 1990)

Wardell, J.W., *A History of Yarm* (Conyers School, 1989)

Wilkinson, M., Victorian Eaglescliffe (Tomorrows History Project, 2002)

Wilson, M.E., Rambling on and about Eston and Normanby, (A.A. Sotheran, 1975)

Wood, R., West Hartlepool (Hartlepool Borough Council, 1980)

Woodhouse, R., Empire Theatre 1897-1987 (Middlesbrough, 1988)

Woodhouse, R., Middlesbrough A Pictorial History (Phillimore, 1989)

Woodhouse, R., Stockton A Pictorial History (Phillimore, 1990)

ARTICLES IN PERIODICALS

Barrow, T., 'Port of Stockton-on-Tees 1702-1802' (paper published by NEEH, 2005)

Blench, E.A., 'The Billingham Enterprise', *Chemistry and Industry*, July and August 1958

Howes, P., 'The Inter-War Development of Billingham', *Cleveland and Teesside Local History Society Bulletin 53*, Autumn 1987

Middlesbrough Football Club, *The Lantern Magazine*, April 1895

UNPUBLISHED WORKS

Billingham Parish Council, *Minutes of meetings 1894-1922*, held in Middlesbrough Reference Library

Billingham Urban District Council, *Minutes of meetings 1922-1939*, held in Middlesbrough Reference Library

Leonard, A., *Haverton Hill, an industrial village on Teesside: the effect of the iron and salt industries on the community and its people in 1851, 1881 and 1891*, final project report for Open University Course DA 301: 2000)

Menzies, P., *An Analysis of the Socio-Economic and Household Structure of Billingham 1861-1881*, unpublished Master of Arts thesis, Teesside University, (1986)

Stockton Rural District Council, *Minutes of meetings 1899-1922*, held in Stockton Reference Library

OTHER SOURCES

Ancestry website, ancestry.co.uk, Births, Marriages and Deaths Index, Military Records 1914-1918, Census Records 1841-1901

Billingham Express, *various editions from 1952 to 1966*, available on microfiche at Middlesbrough Reference Library

Billingham Press, *various editions from 1946 to 1952*, available on microfiche at Middlesbrough Reference Library

Cleveland and Teesside Local History Society: History of Middlesbrough in maps (Middlesbrough 1980)

Cleveland and Teesside Local History Society: History of Stockton in maps (Middlesbrough 1982)

Cleveland and Teesside Local History Society: History of River Tees in maps (Middlesbrough 1990)

Evening Gazette Teesside, *various editions from 1899 to 1968*, available on microfiche at Middlesbrough Reference Library

Hartlepool Mail, *photographic material* held at Teesside Archives

Middlesbrough Extension map 1856 held at Teesside Archives

Norton Heritage Group, A Village Story II (Norton: 1982)

Norton Heritage Group, A Village Story III (Norton: 1987)

Ordnance Survey, 6 inch series, Sheets 44, 45, 50, 51 (1857, 1897, 1916)

Ordnance Survey, 25 inch series, Sheets 44, 45, 50, 51 (1857, 1897, 1916)

Smallwood Album US742, held at Teesside Archives

Stockton and Teesside Herald, *various editions from 1919 to 1940*, available on microfiche at Middlesbrough Reference Library

Stockton Local History Journal, *Notes on Teesside Rail Stations* (April 2006)

Stockton Museums Service, *Discover Cowpen Bewley* (Stockton Borough Council, 2007)

Stockton Museums Service, *various ephemera from the opening of Billingham Council Offices* (1930)

'The Industries of Stockton 1890' originally 1890, reprinted 2002 edited by Tufts P.,

The Times, *Online Archive 1785-1985*, (Times Newspapers, 2008)

The Diaries of Ralph Jackson 1749-1790 - consulted 1982-1992 at Middlesbrough Reference Library but now available at Teesside Archives.

Various *oral interviews* conducted between 1978 and 2008, typed up as statements of individual memories

In addition a large number of *Trade Directories for County Durham and North Yorkshire*, covering the period 1828 to 1939 have been consulted and used to provide and verify information.